HOW TO
IDENTIFY
BENNINGTON
POTTERY

RICHARD CARTER BARRET

DIRECTOR-CURATOR OF
THE BENNINGTON MUSEUM

1964

THE STEPHEN GREENE PRESS

BRATTLEBORO, VERMONT

INTRODUCTION

THE PURPOSE of this guide, as its title indicates, it to tell and to show, as clearly as possible, which pieces of pottery or porcelain were made at the potteries at Bennnington and which pieces were not. Obviously, while I do clarify the major areas of confusion, I could not include every known piece within the compass of a 72-page book. Therefore, from time to time I will refer to my *Bennington Pottery and Porcelain* (published in 1958 and still in print), which identifies and illustrates 2000 items.

It is not difficult to learn how to identify the dozen or so types of pottery and porcelain wares made at Bennington. With very little experience any collector or dealer can become familiar with all the different kinds of wares produced at the two potteries which made Bennington, Vermont, famous in the field of American ceramics.

When you learn that the Bennington potteries produced a great variety of kinds, colors and materials, you have already won half the battle. For some unknown reason, many people believe that a heavy, mottled-brown, kitchen-like type of pottery was the only kind of pottery made at Bennington. They also think that all mottled-brown pottery in existence was made at Bennington. Nothing could be more false.

There were two potteries at Bennington. The oldest one was the Norton Pottery, which made gray Stoneware from 1793 until 1894. This one hundred and one years of continuous production is a record unique in Vermont potteries and enviable in any business today. The other pottery was under the direction of Christopher Webber Fenton, who was married to the granddaughter of Capt. John Norton, the founder of the Norton pottery. The Fenton Pottery began independent operation about 1847, after a brief partnership between Fenton and his brother-in-law, Julius Norton, which started two years earlier in 1845.

Christopher Webber Fenton is regarded as being one of the greatest American potters of his time. He was the first producer on this continent of a lovely white porcelain called Parian Ware. The type of wares he made and sold include a formidable list: Common Yellow Ware, Common White Ware, Mortar Ware, Graniteware, a

variety of porcelains from the famous Parian Ware and Colored Porcelains, to the highly glazed white dinner ware and also the famous brown Rockingham, the brilliant Flint Enamel Wares, Slip-covered Redware and the rare but little-known Scroddled Ware.

The above list of wares shows how impossible it is to identify any one ceramic ware with only the geographical word "Bennington." It is impossible to say with intelligence "I have a Bennington pitcher" and have it mean anything. You may have a Bennington Flint Enamel pitcher (if it's brown with specks of color·as in Fig. 19). You may have a Bennington Graniteware pitcher (if it's glazed white as in Fig. 15). You may have a Bennington Scroddled Ware pitcher (if it's variegated as in Fig. 20). You may have a Bennington glazed white porcelain pitcher (if it's gold-banded as in Fig. 25). You may have a Bennington Rockingham pitcher (if it's mottled-brown as in Fig. 51). You may have a Bennington Parian pitcher (if it's unglazed as in Fig. 57). You may have a Bennington blue and white pitcher (if it's colored as in Fig. 59). You may have a Bennington majolica-type pitcher (if it's an experimental piece as in Fig. 77). But—and this is basic to your understanding of the production—you never, never can have a plain "Bennington" pitcher. You must use another word along with the word "Bennington" to describe what kind of a pitcher you have that was made in Bennington. When you understand this, the rest is fun.

It has been estimated that about only one-fifth of the production of Fenton's pottery was marked. Some of the items are almost always marked, while others have never been found with a mark of any kind. Three marks were used primarily on items made of Parian Ware, or blue and white porcelain. And there were at least four variations of what is called the "1849" mark which was used primarily on Rockingham or Flint Enamel production. One mark was used almost exclusively on Scroddled Ware. All of these marks are illustrated in this guide.

Apparently there was no particular control over the marks, or requirements dictating which mark should be used on what product. Some items have had five different marks recorded on as many separate pieces of the same design. Flint Enamel marks have been found on Parian, and vice versa. There is mainly only a curiosity value to these variations, as they do not contribute anything important to our knowledge.

We mentioned earlier that C. W. Fenton was the artistic proprietor of one of the two potteries in Bennington. His firm was known by several different names: "Fenton's Works," "United States Pottery Company," "Lyman, Fenton & Co." These are the names which appeared on marks used on actual pieces of pottery. There were other names but they were not used on any marks. For a complete history of

the pottery industry in Bennington during the nineteenth century, the reader is referred to John Spargo's book, *The Potters and Potteries of Bennington,* published in 1926.

There is little comparison between the production of the Norton Pottery and that of the pottery operated by C. W. Fenton. To best understand this, compare the two price lists in Figs. 3 and 4. You will see the tremendous variety, both in materials as well as items offered by Fenton, as compared with the Stoneware and the few Rockingham items offered by Norton even fifteen years later, after Fenton had closed his pottery and left town. It is the production of the Fenton Pottery which is so sought after today, although the Norton items have great merit, especially the so-called "hound-handled" pitchers advertised in Fig. 4 and illustrated in Figs. 51 and 52.

The combined production of the potteries at Bennington puts their ceramic output in a comparison class with the glass items produced at Sandwich, Mass. In their respective days, each factory's production was large, among the largest in the United States. I do not think it an unlikely comparison to state that Bennington is to pottery what Sandwich is to glass. Both are names of towns which are often erroneously used as types of production, and they both produced wares which are highly collectible and frequently valuable.

It would not be amiss here to explain why a guide of this sort cannot intelligently include valuations or prices. As you must easily realize, it takes only two people bidding for the same item at a public auction to establish a record of a high sale price, which is not necessarily an indication of its value on an open market. Also, the integrity and the reputation of a dealer affects prices, as does location within a particular area, as well as the geographical areas themselves. And after a price list has been published, it soon becomes out-dated and is of no current value. Therefore, I have purposely omitted any indication of values, limiting this book to the all important task of identification.

I have based the text and selected the illustrations on the hundreds of letters I receive annually and the thousands of questions I am asked at Bennington Museum in the course of my work. I have made a sincere attempt to be straightforward in my answers, and, as you will read, I do not hesitate to state: "I don't know." There are some fields of knowledge where positive statements are an indication of either ignorance or intention to deceive: as our knowledge grows, the less we use the words "always" and "never." I hope this guide proves to be a help to you in your search for the ceramic wares made at Bennington.

Bennington Museum　　　　　　　　Richard Carter Barret
Bennington, Vermont
June, 1964

Sister Wettaw

Bo't of NORTON & FENTON,

		DOZ.	$
JUGS.—4 gall. per doz............	$8,00		
3 " "6,50		1 63	
2 " "4,50		2 25	
1 " "3,00		3	
1-2 " "1,75		1	
1-4 " "1,00			
1-8 " " 75			
POTS.—6 gall. per doz........12,00			
5 " " 10,00			
4 " "8,00	1/2	4 00	
3 " "6,50	1/2	3 25	
2 " "4,50	1/2	2 25	
1 " "3,00			
1-2 " "1,75			
CHURNS.—6 gall. per doz......12,00			
5 " "10,00			
4 " "8,00	1/3	2 66	
3 " "6,50	1/3	2 17	
2 " " 4,50			
JARS, COVER'D.—4 gall. per doz..8,50			
3 " " ..7,00			
2 " " ...5,00			
1 " " ..3,50			
1-2 " " ..2,00			
1-4 " " ..1,50			
PUDDING POTS.—1 gall. per doz. 3,00			
1-2 " " ...1,75			
BEER BOTTLES.—1-4 gal. per doz.1,00			
EARTHEN PANS. —per doz......1,25			

		DOZ.	$
BUTTER POTS.—6 gall. pr. doz. $14,00			
5 " " ..12,00			
4 " " ..10,00			
3 " " ..8,00			
2 " " ..6,00			
1 " " ...4,00			
PITCHERS.—2 gall. per doz......4,50			
1 " "3,00			
1-2 " "1,75			
1-4 " "1,00			
FANCY PITCHERS.—1 gal. pr. doz 5,00			
1-2 " " 3,50	1/6	59	
1-4 " " 2,50	1/2	1 25	
FLOWER POTS.—2 gall. pr. doz. 4,50			
1 " " ...3,00			
1-2 " " ...1,75		88	
1-4 " " ...1,25	1	1 25	
FANCY FLOWER do.—2 gal. pr. doz. 7,50			
1 " " 5,00			
STOVE TUBES.—1st size, per doz. 6,50			
2d " " ...4,50			
3d " " ..3,00			
CHAMBERS.—1st size, pr. doz....2,00			
2d " "1,50			
INK STANDS.—1st size, pr. doz. 1,00			
2d " "50			
MUGS.—qt. per doz..............1,00			
pt. "75			
WATER FOUNTAINS.—per gallon, 25			

$22,96

Add 1 2 Gal Pot.

Recd Payment *20 pet D's* —

Norton & Fenton

$43 73

43 30

8 6 6

$34 6 4

Fig. 1. List of Norton-Fenton Stoneware production and prices, 1845.

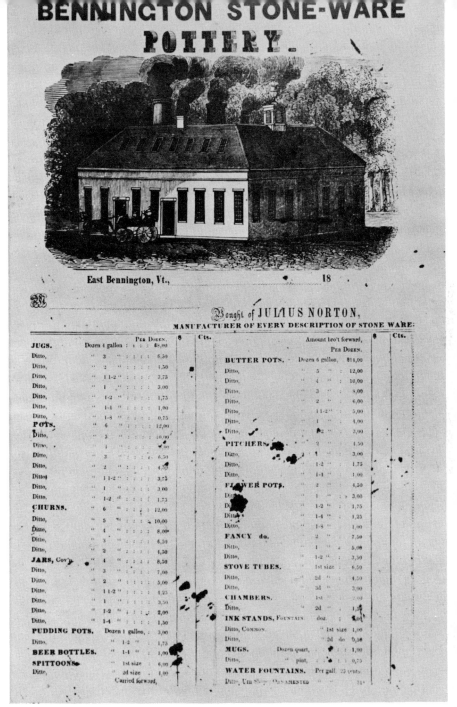

Fig. 2. Norton Stoneware production and prices, 1847-1850.

FENTON'S PATENT FLINT ENAMEL WARE,

MANUFACTURED IN BENINGTON, VERMONT.

ARCHITECTURAL WORK MADE TO ORDER.

General Agency for the United States, . . . 35 Tremont Row.

Boston, *July 20 1852*

Mr. P. Wheldin & Son

Bought of W. H. FARRAR, Gen'l Ag't. *71 56*

GRECIAN TEMPLES, each.	$100 00		
WATER URNS,	per doz.	80 00	
SODA FOUNTAIN DOMES,	"	40 00	
COFFEE URNS,	"	36 00	
STOVE	do.	"	21 00
SLOP JARS, 1st size,	"	59 00	
do. 2d "	"	33 00	
FOOT BATH, 1st size,	"	36 00	
do. 2d "	"	21 00	
EWERS, 1st size,	"	8 00	
do. 2d "	"	7 00	*3 50*
WASH BASINS, 1st size,	"	5 00	
do. do. 2d "	"	4 00	*2 00*
CHAMBERS, 1st size,	"	8 00	
do. 2d "	"	6 50	*3 25*
BED PANS,	"	12 00	
BREAD BOWLS, 1st size,	"	4 00	*1 00*
do. do. 2d "	"	3 00	*75*
SOAP BOXES,	"	4 50	*1 12*
BRUSH do.	"	4 50	*1 13*
SPITTOONS, 1st size,	"	12 00	
do. 2d "	"	8 00	*2 00*
do. 2d "	"	5 00	*1 25*
do. 4th "	"	3 50	*87*
DENTIST,	"	96 00	
PITCHERS, 6 qt.	"	12 00	
do. 4 qt.	"	8 00	*2 00*
do. 3 qt.	"	6 00	*3 00*
do. 2 qt.	"	4 50	*4 50*
do. 1 qt.	"	3 50	*3 50*
do. 1 pt.	"	2 50	*1 25*
do. ½ pt.	"	2 00	*1 00*
MOLASSES PITCHERS,	"	2 25	
COFFEE POTS, 1st size,	"	12 00	
do. do. 2d "	"	9 00	
do. do. 1 cup,	"	2 50	
TEA POTS, 1st size,	"	7 00	
do. do. 2d "	"	4 50	*2 25*
do. do. 3d "	"	3 50	*1 75*
do. do. 4th "	"	2 75	*1 37*
do. do. 1 cup,	"	2 00	
SUGAR BOWLS, 1st size,	"	4 50	
do. do. 2d "	"	3 00	*1 50*
CREAMERS,	"	2 00	*1 00*
PIPKINS, 1, 2, 3, 4,	"		*2 00*
7.50, 6.00, 4.50, 3.50,			
CAKE PANS, 1, 2, 3, 4,	"		*2 75*
6.00, 4.50, 3.00, 2.50			
OVAL BAKERS, 1st size, per doz. 4 00			
do. do. 2d "	"	3 50	
do. do. 3d "	"	3 00	*1 50*
do. do. 4th "	"	2 75	*2 75*
do. do. 5th "	"	2 50	*2 50*
do. do. 6th "	"	2 25	*2 25*
NAPIES, 8, 7, 8, 5, 10, 11 in.			*9 00*
.75, 1.00, 1.25, 1.50, 2.00, 2.50			
PIE PLATES, 8, 9, 10, 11 in.			*7 50*
.75, 1.00, 1.50, 2.00			
LIPP CAKE PANS, 1st size, "	6 00		
do. do. do. 2d "	"	4 50	
TURK'S HEAD C PANS,			
1, 2, 3, 4, 5,			*1 62*
2.25, 4.50, 3.50, 2.00, 1.00			
MILK PANS, 1, 2, 3, 4, 5,			
4.50, 3.50, 2.75, 2.25, 1.75			
BUTTER PLATES, per doz. 8.00			
SOUP do. " 1 50			
PICKLE do. " 1 75			

FLOWER VASES, 1st size, per doz. 4 50			
do. do. 2d "	"	3 50	
FLOWER POTS, 1st size,	"	9 00	
do. do. 2d "	"	6 00	
do. do. 3d "	"	4 50	
PRESERVE JARS, 1st, 2d, 3d, 4th,			*2 50*
2.50, 3.00, 4.50, 6.00			
ROUND DO.	per doz.	2 50	
PLUG BASINS, 14 inch,	"	18 00	
do. do. 12 "	"	16 00	
GOBLETS,	"	1 50	
FLANGE MUGS, 1st size,	"	1 50	
do. do. 2d "	"	1 00	*1 00*
TUMBLERS,	"	1 00	*1 00*
TOBIES,	"	2 25	*38*
CANDLESTICKS, 1st size,	"	4 50	
do. 2d "	"	3 50	
do. 3d "	"	2 75	
do. LOW, 1st "	"	4 50	
do. do. 2d "	"	4 00	
do. do. 3d "	"	3 50	
BOTTLES, (Fancy),	"	4 00	
BOOK, do. 4 qts.	"	12 00	*2 00*
do. do. 2 qts.	"	8 00	
do. do. 1 pt.	"	5 00	*84*
POCKET FLASKS,	"	3 00	
WAFER BOXES,	"	3 00	
SHOVEL PLATES,	"	4 50	
PICTURE FRAMES, ½ plate "	10 00		
do. do. ¼ plate "	7 50		
do. do. ⅓ plate "	4 00		
do. do. ¼ plate "	3 00		
Lamp Base & Pedestal, 13 inch, "	18 00		
do. do. 9 "	"	12 00	
do. do. 3 "	"	9 00	
SIGN LETTERS, 12 inch,	"	12 00	
do. do. 6 "	"	4 80	
do. do. 3 "	"	1 50	
DOOR PLATES, (Parian Marble), "	12 00		
do. do. Enameled, "	6 00		
NUMBER DO. with Figures, "	2 00		
CURTAIN PINS,	"	4 00	
FURNITURE NOBS,	"	75	
DOOR NOBS, Parian Mable, "	4 00		
do. do. Enameled, "	3 00		
Fancy Articles.			
DOG WITH BASKET, per doz.	13 00		
LIONS,	"	18 00	
do. on Base,	"	24 00	
COW CREAMERS,	"	4 50	
SWISS LADIES,	"	3 50	
STAGS & DOES,	"	24 00	
COWS RECLINING,	"	24 00	
Figures in Parian Marble			
ADORATION,	per doz.	75 00	
CUPID,	"	30 00	
INDIAN QUEEN,	"	24 00	
HOPE,	"	12 00	*1 00*
GOOD NIGHT,	"	12 00	*1 00*
GREY HOUND,	"	12 00	*1 00*
SWAN,	"	12 00	*1 00*
SAILOR BOY AND DOG, "	4 00		
MUSTARD CUP,	"	4 00	
SHEEP,	"	4 00	*1 00*
BIRD NESTS,	"	3 00	
Parian Marble			
PITCHERS, No. 1,		12 00	
do. 2,		10 00	
do. 3,		8 00	
do. 4,		4 00	

71 56

Less rej'd cont. *87 11*
8 71
78 40
1 Book & Box Hosting *1 25*

Fig. 3. Important list of production items made by Fenton, 1852.

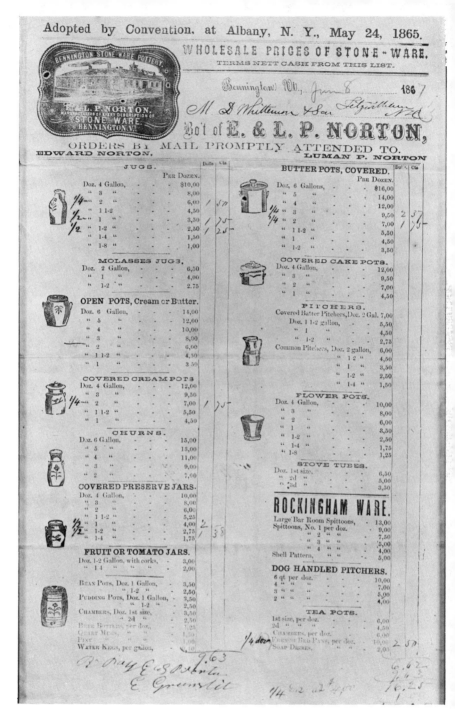

Fig. 4. Norton production. Note Rockingham items added by 1865.

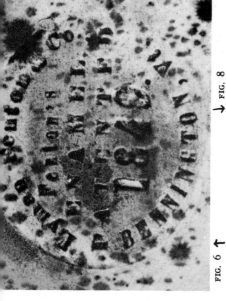

FIG. 6 ↑ FIG. 8 →

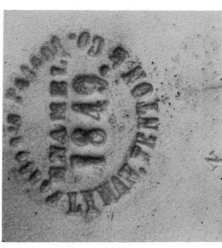

↓ FIG. 7

FIG. 5 ↑

Used until 1858, these four Fenton marks were impressed mainly on his Flint Enamel and Rockingham wares, when used. Fig. 6, the most common mark, is frequently called the "1849 mark," even though this date is also prominently featured on the other three. Fig. 5 and 8 are the rarest marks.

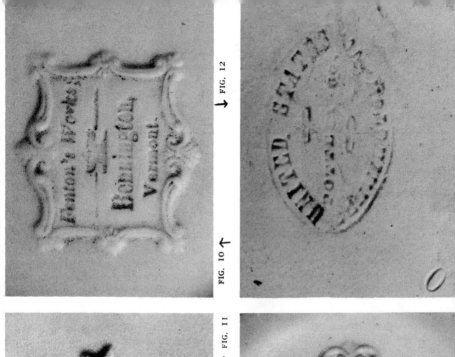

FIG. 10 ← → FIG. 12

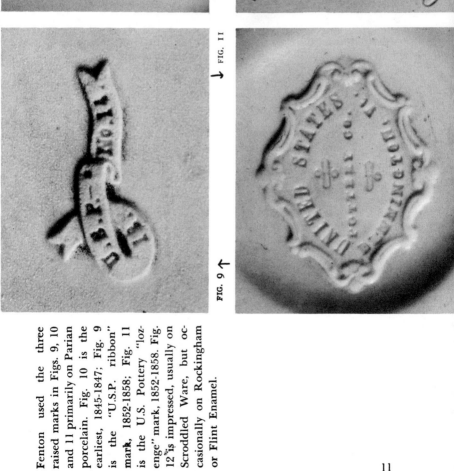

FIG. 9 ↑ → FIG. 11

Fenton used the three raised marks in Figs. 9, 10 and 11 primarily on Parian porcelain. Fig. 10 is the earliest, 1845-1847; Fig. 9 is the "U.S.P. ribbon" mark, 1852-1858; Fig. 11 is the U.S. Pottery "lozenge" mark, 1852-1858. Fig. 12 is impressed, usually on Scroddled Ware, but occasionally on Rockingham or Flint Enamel.

11

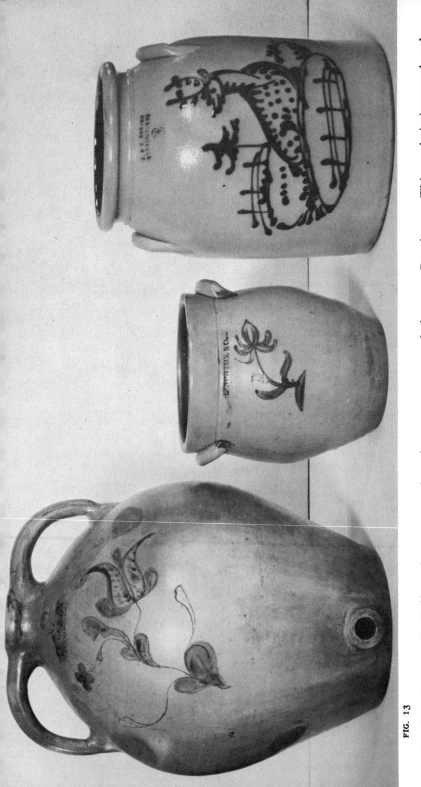

FIG. 13

Question: How can I tell if my Stoneware crock or jug came from Bennington? **Answer:** Stoneware items made in Bennington after 1823 are marked with the name of the Norton Com-

pany and the town Bennington. This mark is impressed and frequently had cobalt rubbed into the letters. If Stoneware is not marked, it is almost impossible to identify manufacturer.

Question: How can I tell the age of a Bennington Stoneware crock, jug or other item? **Answer:** From the mark of the maker's name and town which is impressed on the piece. Various changes occurred in the mark from time to time, but it always had the name "Norton" appearing in some combination. The following is a chronological list. Note the slight differences in the use of "Co." and "Company," "Bennington" and "East Bennington."

MARKS USED	DATE USED
L. Norton & Co. (no town name)	1823-1828
L. Norton & Co., Bennington, Vt.	
L. Norton, Bennington, Vt.	1828-1833
L. Norton & Son, Bennington, Vt.	1833-1838
L. Norton & Son, East Bennington, Vt.	
Julius Norton, Bennington, Vt.	1838-1845
Julius Norton, East Bennington, Vt.	
J. Norton, East Bennington, Vt.	
Norton & Fenton, Bennington, Vt.	1845-1847
Norton & Fenton, East Bennington, Vt.	
Julius Norton, Bennington, Vt.	1847-1850
J. Norton, Bennington, Vt.	
J. & E. Norton, Bennington, Vt.	1850-1859
J. Norton & Co., Bennington, Vt.	1859-1861
J. & E. Norton, Bennington, Vt.	
E. & L. P. Norton, Bennington, Vt.	1861-1881
E. Norton, Bennington, Vt.	1881-1883
Edward Norton, Bennington, Vt.	1883-1894
Edward Norton & Co., Bennington, Vt.	
Edward Norton & Company, Bennington, Vt.	
E. Norton & Co., Bennington, Vt.	
Edward Norton Company, Bennington, Vt.	1886-1894

The mark used 1861-1881 (E. & L. P. Norton, Bennington, Vt.) is the most common mark; it was in use longest and included the period of increased production immediately following the Civil War.

Question: Was all the pottery made in Bennington marked?
Answer: Identification should be so easy! The answer is an emphatic "No," as only about one-fifth of Fenton's production was marked in any way, and Norton only marked his Stoneware. But if it were always

marked, it wouldn't be any fun trying to identify it. **Question:** I have a jug decorated with a spray of odd looking flowers, painted on the surface in shiny blue. The mark is: "J. & E. Norton, Bennington, Vt." Does the color or type of decoration indicate age? **Answer:** Not in itself. Some early pieces were decorated with the same cobalt blue as some later pieces. However, on the early pieces the blue was thin and frequently dull. Other times, ochre was used which resulted in brownish-yellow decorations. The designs on the early pieces were sometimes scratched or incised into the pottery, with the cobalt rubbed into the lines. Your jug may be dated from the mark, however, and was made between 1850-1859.

Question: Did the Norton firm make anything except Stoneware items? **Answer:** Yes. The price list illustrated in Fig. 4 shows that they made a limited number of items in the popular mottled-brown Rockingham ware, including 4 sizes of the famous hound-handled pitchers illustrated in Fig. 52. **Question:** A dealer told me that there is a difference between early Rockingham and that which was produced later. Is this so? **Answer:** The answer to this must be a qualified "Yes." It depends on what you mean by the terms "early" and "later" Rockingham. The manufacture of Rockingham probably commenced around 1841. By 1845 the Rockingham, or "dark lustre" as it was made in Bennington, was solid brown. The biscuit piece was completely dipped into a glaze made of feldspar, flint, red lead and clay, with the brown color being supplied by a small amount of manganese. This was the method of making Rockingham until 1847 at least. By 1849 it became the mottled-brown ware which is currently all we think of when we use the term "Rockingham." **Question:** I understand that Norton took his son-in-law Christopher Webber Fenton into partnership with him. Did the firm "Norton & Fenton" make anything beside crocks, jugs and other Stoneware items? **Answer:** Yes. They made the six-sided brown pitchers illustrated in Fig. 14. These pitchers are the only known items other than Stoneware pieces made by this partnership, which lasted only from 1845 to 1847. The price list shown in Fig. 1 lists the known items produced by February, 1845. Yet the six-sided pitchers were made before the partnership was dissolved in June, 1847. These pitchers have the name of the firm impressed on the bottom in two styles: one in two straight lines with "Norton & Fenton" on the top line, and the location "Bennington, Vt." on the bottom line. The other style, a rarer mark, had the same words arranged in a circle.

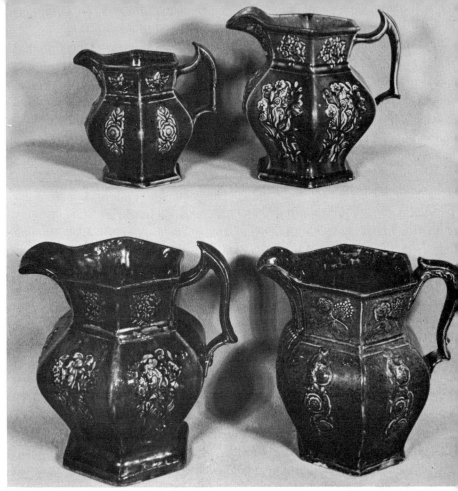

FIG. 14

Question: How can I tell if my six-sided brown pitcher was made in Bennington? **Answer:** This is very simple, as only those pitchers marked with the name "Norton & Fenton" can be identified as made in Bennington. Pitchers of this type were made by many different manufacturers, and if they are not marked the place of production cannot be established. **Question:** Were all the Norton & Fenton Rockingham pitchers the same size and same design? **Answer:** No. As you can see in Fig. 14, they were made in at least four different sizes, the smallest illustrated being 7″ high, the largest 11″ high. All four pitchers are different in design, having a variety of raised floral designs on the side panels and also a variation of handle shapes. There is also a variety of curves evidenced in the panel shapes.

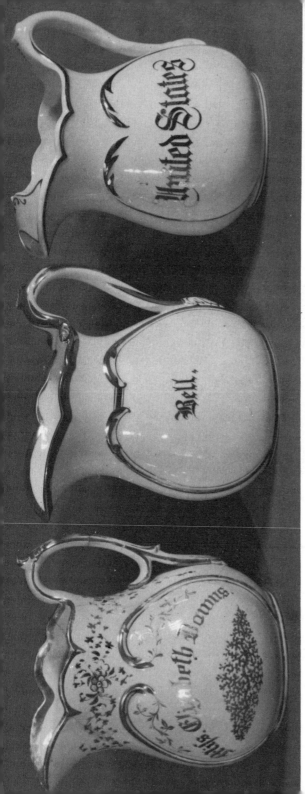

FIG. 15

Question: Did Bennington ever make a highly glazed white pitcher, with gold decorations which included someone's name? I have one like this which is 7½″ high. **Answer:** Yes, if your pitcher matches Fig. 15(a) in shape it was made in Bennington. These are called "Sweetheart" or "Presentation" pitchers, made of Graniteware, and are known in at least eight different sizes, from 4⅜″ high to 9½″. Handles with divided brace at the bottom are easiest to identify as Bennington-made. The pitchers were also made with a twisted handle, split at the top, and ending in a simplified leaf form. See Fig. 15 (b). BE CAREFUL: The pitcher illustrated in Fig. 15(c) was NOT made in Bennington. It is exactly the same design as Fig. 15 (b) except for the ice shield, but it also was made without ice shield. These were made by the Houghwout & Co. Pottery at Greenpoint, Brooklyn, and cannot be distinguished from Bennington ones without historical evidence. These are sometimes called "St. Nicholas pitchers" because of the large number made at Greenpoint for the St. Nicholas Hotel which opened in 1854 in New York City.

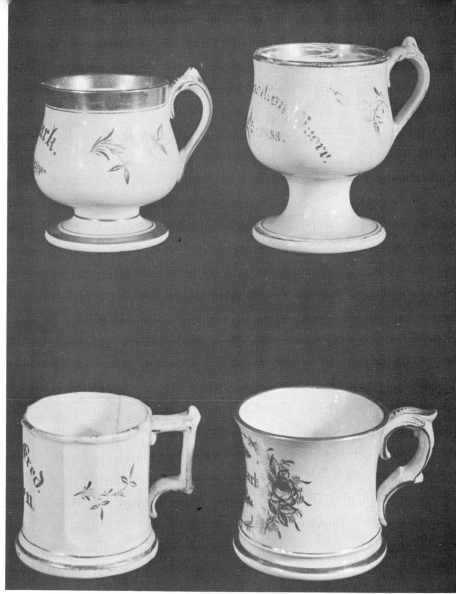

FIG. 16

Question: How can I tell if my glazed white mug with a name in gold was made in Bennington? **Answer:** This is hard and cannot always be done. If your mug matches exactly any of the four illustrated in Fig. 16, you'd be safe to identify it as Bennington-made. BE CAREFUL: Shaving mugs in this material were made at most potteries in America and abroad, and were gold decorated.

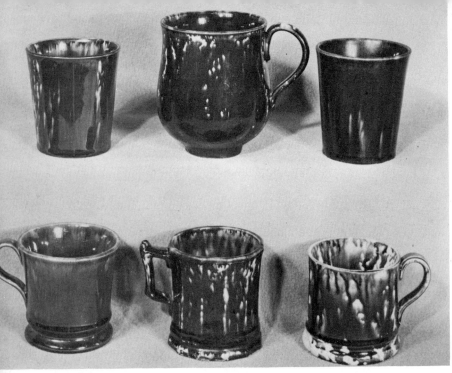

FIG. 17

Question: Is there any way I can identify a mottled-brown mug as a Bennington-made piece? Answer: Yes. Of course the easiest way is to find a marked one! However, these are extremely rare, and if you only collect marked pieces I'm afraid that you will probably do without mugs! There is one marked example known, so there are probably others somewhere. The mug with the 1849 mark (Fig. 6) is illustrated in Fig. 17(e) and Fig. 18(b). Notice also that the Graniteware mug (c) in Fig. 16 is the same pattern. If you can't find a marked mug, the next best way to identify one is to match one with the mugs illustrated in Figs. 17 and 18. Question: Are all the brown mugs made at Bennington illustrated in Figs. 17 and 18? Answer: It is not safe to say positively that they are, because handles were interchanged, so it is highly possible that mugs exist which have the body from one illustration with the handle from another. These variations are endless, and obviously are impossible to record in every instance. But if you find a match of the body of one and the handle of another, it is fairly safe to say that your mug was made in Bennington. Also, there may be additional mugs with other forms, about which nothing is known at the present time. However, the mugs illustrated are the ones most likely to be found.

18

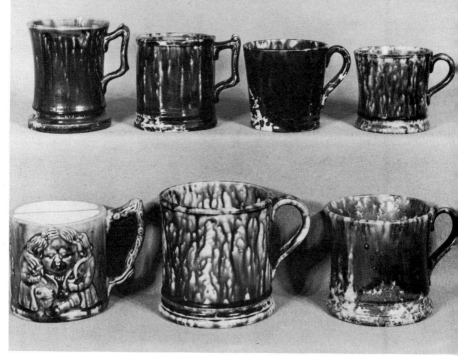

FIG. 18

Question: Did Bennington ever make mugs in Flint Enamel glaze? **Answer:** Not that is known. There is no good reason why they shouldn't have, but so far there has been no record of any made in this ware. The elaborate toilet sets in Flint Enamel should have had a matching mug for shaving, as did the various Graniteware sets. Perhaps you will be the lucky one to find the first example. BE CAREFUL: The mug illustrated in Fig. 18(e) is sometimes found in a very light yellowish brown which might be confused with some types of Flint Enamel. This mug was NOT made at Bennington but was a product of Bennett Bros., Baltimore, Md. It is included here because of the resemblance of. the toby figure on its side to the Bennington-made toby snuff jars illustrated in Fig. 44. **Question:** I'd like to collect a table setting of mugs and pie plates. Did they make any other articles suitable for this use? **Answer:** Assuming you mean in Rockingham glaze, the answer is Yes. The two beakers illustrated in Fig. 17 (a and c) would be serviceable for any liquid. Goblets (with and without handles, tall or short), pitchers, tea and coffee pots, sugar bowls, relish dishes, covered butter dishes, assorted bowls and bakers—a complete table service, except cups and saucers and regular plates, was made.

19

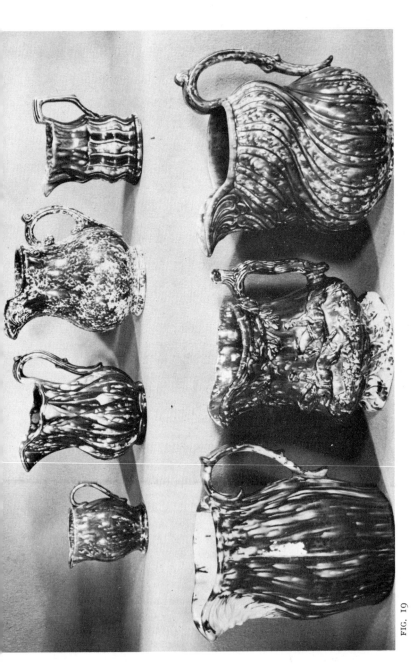

FIG. 19

Question: How can I be sure that my brown pitcher was made in Bennington? It has no mark on it. **Answer:** There is no positive way of identifying all Rockingham (brown) pitchers. See my book, *Bennington Pottery and Porcelain*, wherein I have made an attempt to illustrate all known shapes of pitchers. There were a great number of different patterns made at Bennington.

Comparison of your pitcher with those illustrated would be a great help in the job of positive identification. There were many different patterns made, and up to seven sizes of each pattern, so you see how impossible it would be to attempt to answer your question in a book of this size. BE CAREFUL: The fact that your pitcher may look almost the same as a Bennington-made one by no means identifies yours as a Bennington product also. Patterns were copied by many factories, and the slight differences which appear are the main clues to identification. So if your pitcher isn't marked, and if it doesn't match those known to have been made in Bennington, then you have only eliminated Bennington: you have not identified which of over fifty other American potteries (not to mention an untold number of English potteries) might have produced it. **Question:** Did Bennington ever make pitchers of the same shape, design and size in more than one material? **Answer:** Frequently. The most common occurrence of this is between the two glazes, Rockingham and Flint Enamel. Many of the pitchers made in Bennington were produced in both of these glazes. Occasionally, in addition to these two, the same pitcher was also made in Graniteware and in Red Slip Ware, and even in the rare Scroddled Ware. An example of this is illustrated in Fig. 19(b) compared with Fig. 20(c). **Question:** Are some Bennington-made pitchers always marked, while others are only sometimes marked, and still others never marked? **Answer:** I attempt to avoid as much as possible, use of the two words "always" and "never" with reference to specific pieces, because they are too big, too all inclusive, and too final to use on any subject being studied and researched. While we have been able to identify with positive authority much of the production from the two Bennington potteries, we will undoubtedly never be able actually to complete the production lists. One good reason for this is that we are dealing with a time in the industrial growth of a product which permitted much off-hand, one-of-a-kind production. A potter could make endless varieties using a basic mold and applying all kinds of external decorations and fixtures, handles, spouts, etc. Consequently, it is almost impossible to answer your question without using a lot of qualifying remarks. In Fig. 19, pitcher (a) has so far never been found with a mark; neither has pitcher (c). Pitchers (b), (f) and (g) are frequently marked with the oval 1849 mark in Fig. 6, although sometimes they bear no markings. Pitchers (d) and (e) have been found with the same 1849 mark, but they are more often completely unmarked. And the famous hound-handle pitcher in Fig. 52 has not yet been found with a mark of any kind. So you see how many combinations of designs, sizes, patterns, materials and marks all add up to make this an endless study.

Question: Since you say that many Bennington-made pitchers of the same size and shape are made in different materials, is there any shape or pattern pitcher that was made in all materials? **Answer:** No, there was not, and we can be thankful for this limiting fact as we don't need so many different varieties for a good collection. However, this fact does open up all sorts of fascinating possibilities for a collector. For example, hound-handled pitchers (see Fig. 52) have only been found in Rockingham (see the BE CAREFUL warning on Page 51) without a mark. You would have the only known example if you found one with a Bennington mark. What rarity you would add if you imagined a different material, say Parian, and then throw in a rare mark for good measure. Perhaps you'd prefer to find a blue and white porcelain example with an unrecorded mark, or, as long as we're dreaming, why not a Scroddled Ware hound mounted on a glazed pink porcelain pitcher with the raised design done in Parian? What a nightmare, but if you let your imagination run wild, and keep your eyes open, you may some day find a combination of materials and pattern and size that never has been previously recorded. Finds like these are the dreams (or nightmares) of every avid Bennington collector. **Question:** Were some patterns of pitchers more popular than others and produced in larger quantities so that they are easier to find today? **Answer:** Yes, this is quite true. Among the more plentiful pitchers is the Diamond pattern, Fig. 19 (b) and all four pitchers in Fig. 20; the Alternate Rib pattern, Fig. 19 (g) without the swirl, as the teapot in Fig. 21 (e) and (f), or like the sugar bowl in Fig. 26(d), or the tobacco jar in Fig. 27(d). The Paul and Virginia pitcher in blue and white porcelain, illustrated in Fig. 59, and the Pond Lily pitcher, illustrated in Fig. 65, were very popular designs and still are. However, because these pitchers apparently were produced in larger quantities than some of the other patterns does not mean that they are either less valuable or very common today. **Question:** How can I tell the difference between the Scroddled Ware of Bennington, and Marbled Ware from other potteries? **Answer:** One of the basic things to remember is that Bennington Scroddled Ware has the veins going all the way through the piece so that it looks the same inside as it does outside. Marbled Ware is only a term which has been universally accepted to mean a surface treatment or transfer pattern only; it does not include wares which are striated solidly through their entire body. To understand the difference more easily, imagine a marble cake, part chocolate, part vanilla. If this were pottery it would be called Scroddled Ware if made in Bennington, but Solid Agate or Lava Ware if made in England. Now imagine the same mixture of chocolate and vanilla used only as an icing on a white cake. Pottery such as this is called Marbled Ware.

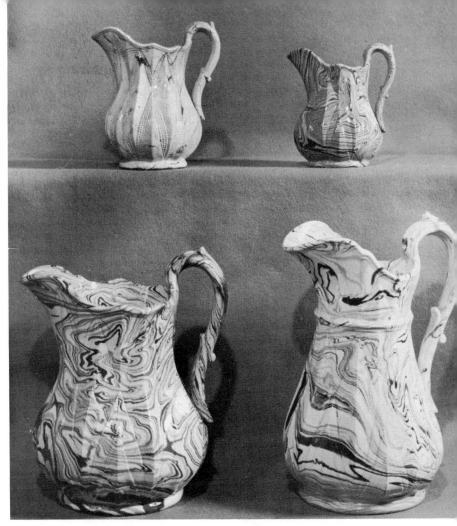

FIG. 20

Question: What is this Bennington Scroddled Ware and how was it made? **Answer:** The four pitchers illustrated in Fig. 20 are all made of Scroddled Ware. It is a variegated pottery, usually a cream background with veins of darker brown streaking through it. It is made by placing layers of different colored clays on top of each other much like a piece of plywood. This was then twisted, pounded and kneaded until thoroughly joined, resembling stratified rock. The wavy layers retain their original colors, the clay was shaped, fired and glazed with clear feldspar. **Question:** Is all Bennington Scroddled Ware marked? **Answer:** No, but when marked it is usually with the mark shown in Fig. 12. Not much Scroddled Ware was made, which makes it the rarest type to find today.

23

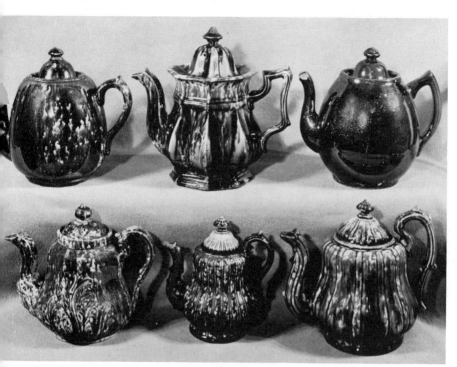

FIG. 21

FIG. 22

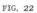

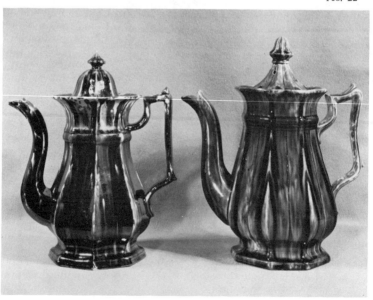

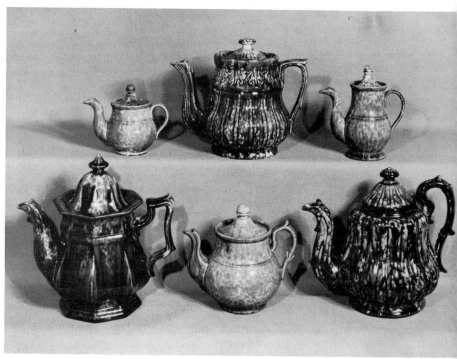

FIG. 23

Question: Were Rockingham teapots made at any pottery other than Bennington? **Answer:** Yes, they were a necessary production item in England and were made there in quantity, as well as in all the other American potteries. **Question:** Then if my teapot isn't marked, how can I tell if it came from Bennington? **Answer:** You can't always tell, but usually you can. The teapots illustrated in the three photos above, Figs. 21, 22 and 23, represent all the known Bennington shapes, although not all the sizes. In Fig. 21, teapots (a) and (c) are known to have been popular shapes and were made at many different potteries, including Bennington. If you have one of these, it is impossible to identify it without a mark or strong personal history or documentation. The other teapots are not known to have been made anywhere else, and are frequently marked with the 1849 mark illustrated in Fig. 6. **Question:** Did Bennington ever make teapots in anything besides the brown Rockingham Ware? **Answer:** Yes, they were also made in Flint Enamel Ware, White Porcelain, and Parian. Two styles of coffee pots were made, as in Fig. 22, but these were made only in Flint Enamel Ware.

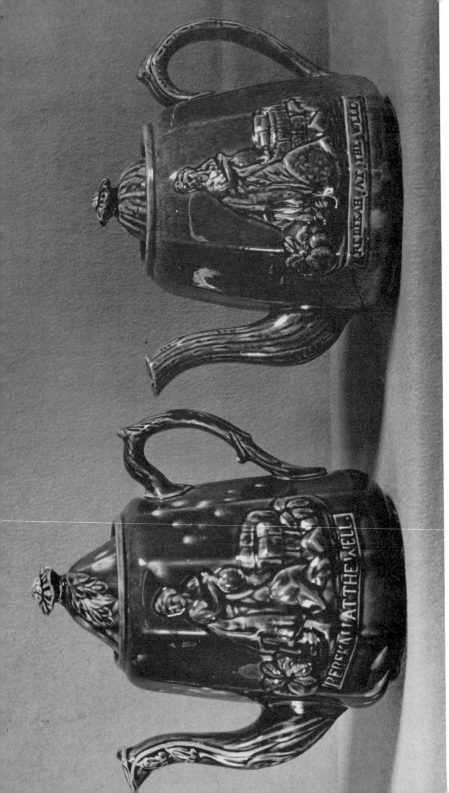

FIG. 24

Question: I have a Rebecca-at-the-Well teapot I was told was made in Bennington. I have seen other teapots with the same design but in a different style. Which one was made at Bennington? **Answer:** None of them. The popular Rebecca-at-the-Well teapot was NOT made at Bennington. Even though this statement has been printed many times, collectors and dealers alike persist in attributing this pattern to Bennington. I know that there are more than several dozen varieties of this one design from almost as many different American potteries, yet for some strange reason Bennington gets all the credit. The large majority of these teapots was made by the skilled firm of Edwin and William Bennett in Baltimore, Maryland. Charles Coxon joined them in 1850 as their chief modeler and he is credited with modeling their famous Rebecca teapot, copying it from one previously made in England by Samuel Alcock & Company. BE CAREFUL: No matter what anyone tells you to the contrary, it is a firmly established fact that no item at all (but especially teapots) bearing the "Rebecca-at-the-Well" design, was ever made at Bennington. **Question:** I have a gold-banded tea set which looks just like the set pictured in Fig. 25. Were all similar pieces made in Bennington, or was this ware also made somewhere else? How can I tell where my set was made? **Answer:** It is next to impossible to tell where the gold-banded tea sets and dinner services were made unless they have factual documentation. The only positive design clue to look for is the

cover knob. Bennington-made pieces have a small, many-pointed star molded at the tip and decorated in gilt. All Bennington-made pieces have this detail, but other potteries may have used it also. This ware was made by every sizeable pottery in America and England.

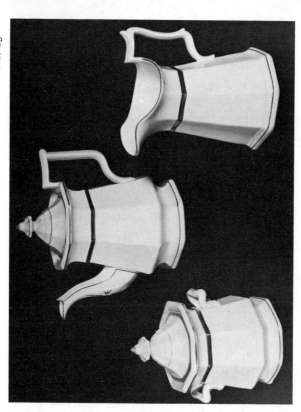

FIG. 25

27

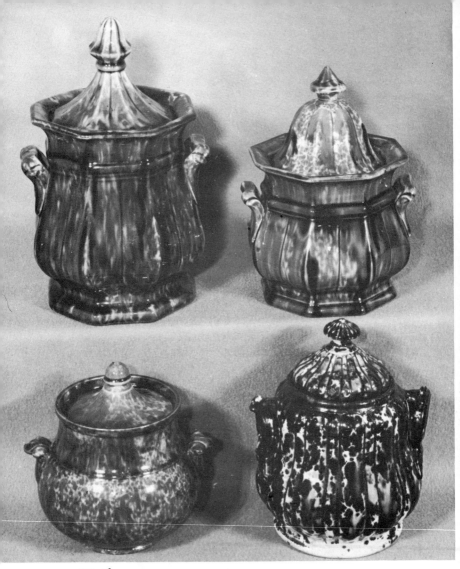

FIG. 26

Question: I have a solid brown, round shape sugar bowl which I have been told was made in Bennington. How can I tell for sure? **Answer:** This is easy. Only four brown colored sugar bowls (not including Parian or Glazed White Porcelain) were made in Bennington. All four are illustrated in Fig. 26 above and are frequently marked. All four were made in Flint Enamel, which is basically brown but with additional spots of color, mainly yellow, blue, and green. Sugar bowl (d) was also made in Rockingham glaze which is mottled brown.

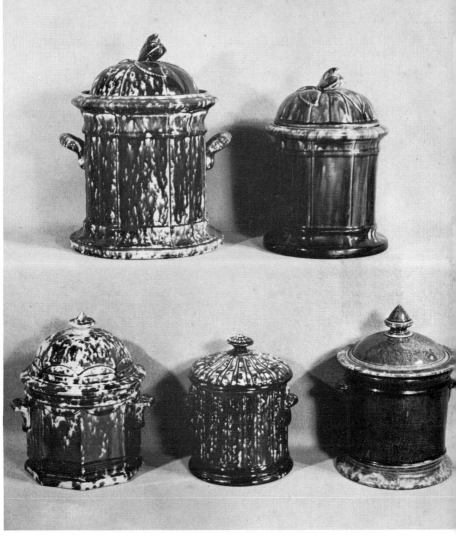

FIG. 27

Question: My tobacco jar cover has a small hole in it. What was that for? **Answer:** The hole was to let steam escape from the pipkin for which your cover was made. This is especially true of the jar in Fig. 27(d). Pipkins for baking were sized the same as tobacco jars. BE CAREFUL: Be sure you have the correct cover. Most covers have an identifying pattern which is repeated from the body of the jar. However, pipkins were made in the same pattern as jar (d), called "Alternate Rib" pattern, as well as plain jar (e).

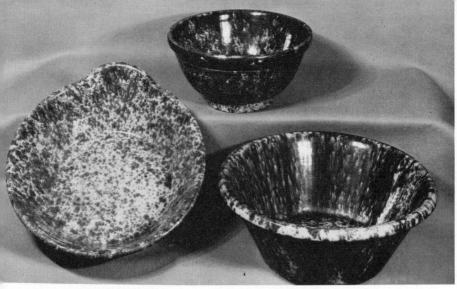

FIG. 28

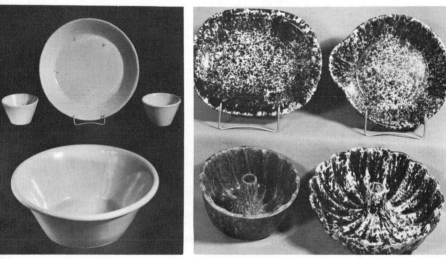

FIG. 29 FIG. 30

Question: I have a mottled-brown mixing bowl which has no maker's mark on it. How can I tell if it were made in Bennington? **Answer:** The easiest way is to first ascertain if it were NOT made in Bennington. If you find raised supports or notches on the bottom (see Fig. 33), or if the outside of the bowl has a molded design (see Fig. 34), your bowl was made somewhere else. **Question:** But my bowl is plain on the outside and on the bottom. Was this type made in Bennington? **Answer:** If in addition to the speckled brown glaze, there are splashes of yellow, green and blue, or one of these colors, and the bowl is

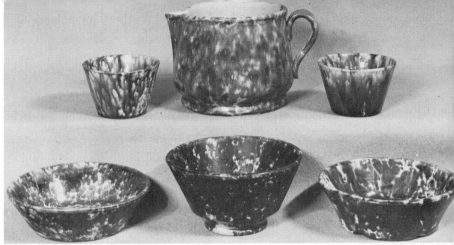

FIG. 31

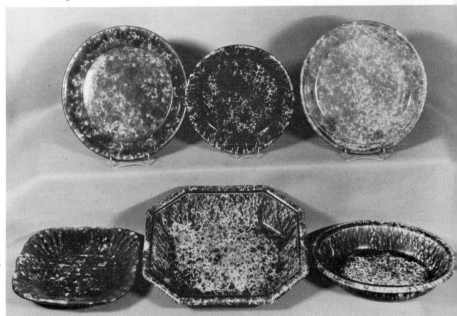

FIG. 32

the same shape as any illustrated in Fig. 28 through Fig. 32, then you have a Bennington-made Flint Enamel bowl, made between 1849 and 1858. Look carefully on the bottom and see if the oval 1849 mark (see Fig. 6) might be faintly impressed. This mark often gets filled with glaze and is then difficult to see. If the bowl is the same shape as those illustrated, it does not need to have any color other than brown. If it is just mottled-brown, it is called Rockingham, rather than Flint Enamel, and dates 1847-1867.

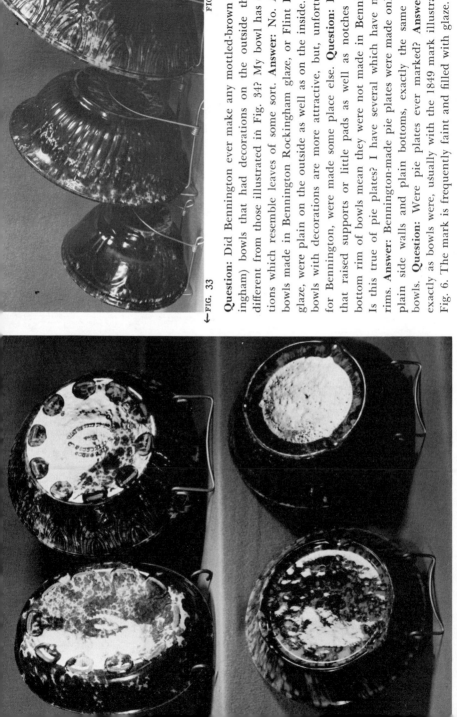

FIG. 33

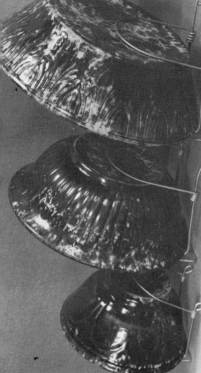

FIG. 34

Question: Did Bennington ever make any mottled-brown (Rockingham) bowls that had decorations on the outside that are different from those illustrated in Fig. 34? My bowl has decorations which resemble leaves of some sort. **Answer:** No. All the bowls made in Bennington Rockingham glaze, or Flint Enamel glaze, were plain on the outside as well as on the inside. Those bowls with decorations are more attractive, but, unfortunately for Bennington, were made some place else. **Question:** I know that raised supports or little pads as well as notches in the bottom rim of bowls mean they were not made in Bennington. Is this true of pie plates? I have several which have notched rims. **Answer:** Bennington-made pie plates were made only with plain side walls and plain bottoms, exactly the same as the bowls. **Question:** Were pie plates ever marked? **Answer:** Yes, exactly as bowls were, usually with the 1849 mark illustrated in Fig. 6. The mark is frequently faint and filled with glaze.

Question: Were all Bennington-made cuspidors marked? I have one which appears to be Bennington-made, but it has no mark. How can I tell where it was made?

Answer: There are some patterns which, if unmarked, cannot be identified positively. The cuspidors in Fig. 34a are perfect examples of this. The one on the left, (a) is marked: ETRURIA WORKS, 1852. EAST LIVERPOOL (Ohio) and the one on the right is marked with the 1849 Flint Enamel mark illustrated in Fig. 6. BE CAREFUL: This word of caution also applies to plain oval baking dishes, as in Fig. 34a. The one on the left (c) came from East Liverpool, Ohio, while the one on the right (d) was made in Bennington. Dark or light color has nothing to do with the place of manufacture. Also, it is next to impossible to identify the place of manufacture of many unmarked pie plates. Actually, all functional items without any pattern details are very difficult to identify as having been made in Bennington.

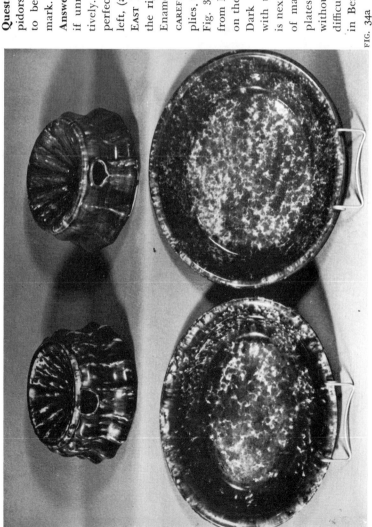

FIG. 34a

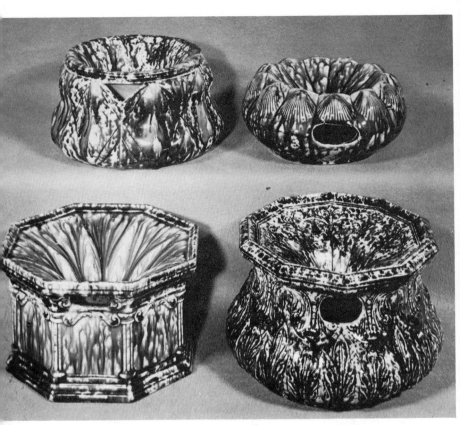

FIG. 35

Question: Are there some patterns of cuspidors that can be identified as having been made in Bennington even though they aren't marked? **Answer:** Yes. All four cuspidors illustrated in Fig. 35 above can safely be attributed to Bennington even without a mark. The two on the top row are the most common designs of these four. Also, the two Scroddled Ware ones in Fig. 37 do not need a mark to identify them. BE CAREFUL: The cuspidors illustrated in Fig. 36 are the most common ones, and if they are unmarked it is impossible to attribute them to Bennington without documentation or history. **Question:** Were most cuspidors marked, and if they were, what mark was used? **Answer:** About half of all the cuspidors which I know can be identified as having been made in Bennington were marked with the 1849 mark in Fig. 6. Some few were in the other 1849 marks in Figs. 5, 7 and 8. Scroddled Ware ones sometimes have the mark in Fig. 12. I have never seen marks in Figs. 9, 10 or 11 on a cuspidor.

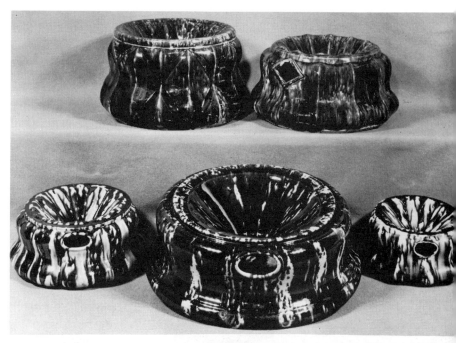

FIG. 36

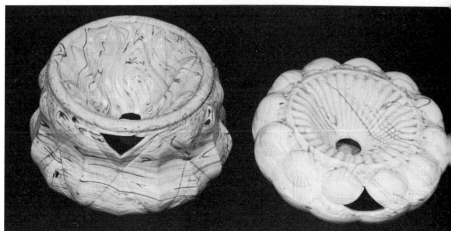

FIG. 37

Question: I have a shell pattern cuspidor in what looks like Scroddled Ware but it has blue veins instead of brown. Was this made in Bennington? **Answer:** Yes, and for some unknown reason blue-veined Scroddled Ware has only been found in the two cuspidors shown in Fig. 37.

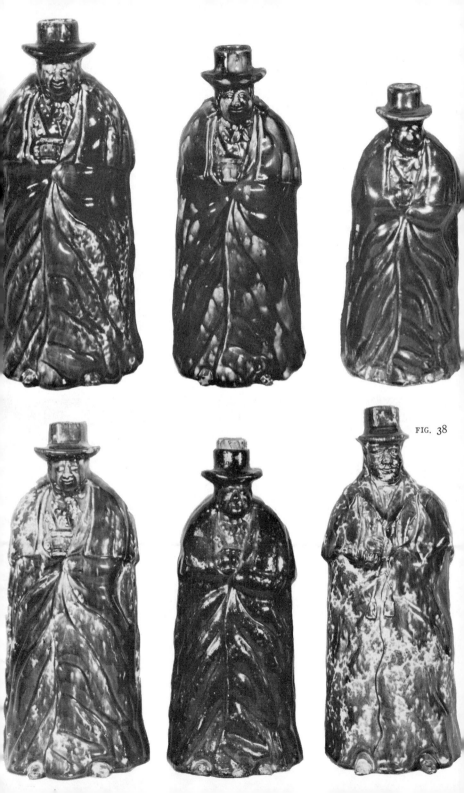

FIG. 38

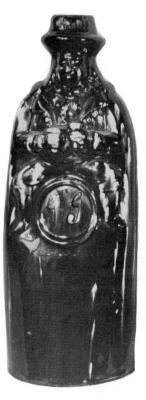
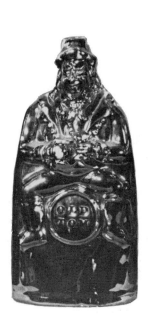
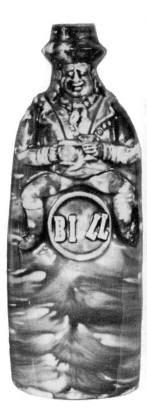

FIG. 39

Question: Were the toby bottles made at Bennington always the same? I have one, but recently saw a different design which the owner claimed was made in Bennington. **Answer:** There were three main designs of these so-called toby or Coachman bottles made at Bennington. These three basic designs then had a variety of glazes, sizes, and materials. They are illustrated in Figs. 38 and 39. The three bottles in the top row of Fig. 38 show the same design in three sizes, the rarest of which is the smallest, (c) being 8½ inches high. The bottles on each end of the bottom row, (d) and (f), show two of the basic designs, (d) having a short hat and no tassels at waist while (f) has a tall hat, tassels at waist and a mustache. Fig. 29 shows the rarest design, man astride a barrel. Sometimes initials or short names were either incised or applied to the barrel head, but usually it was left blank. The small one in the center (b) is 8 inches high and the rarest size.
Question: Are the toby bottles always Rockingham, and were they ever marked? **Answer:** They were made in Rockingham, Flint Enamel, and Graniteware and were frequently marked with the 1849 mark in Fig. 6.

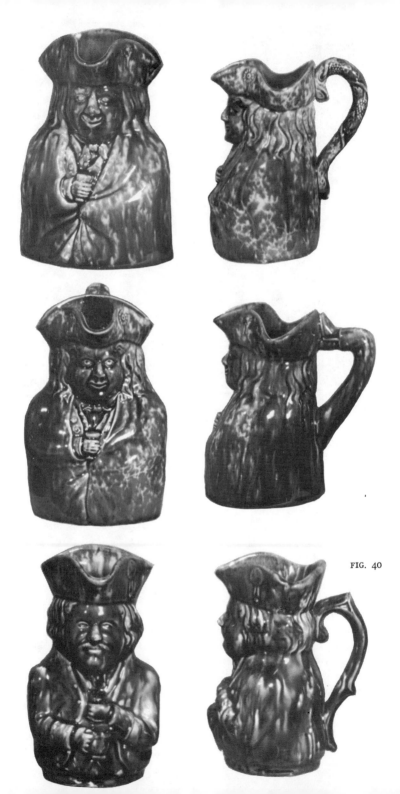

FIG. 40

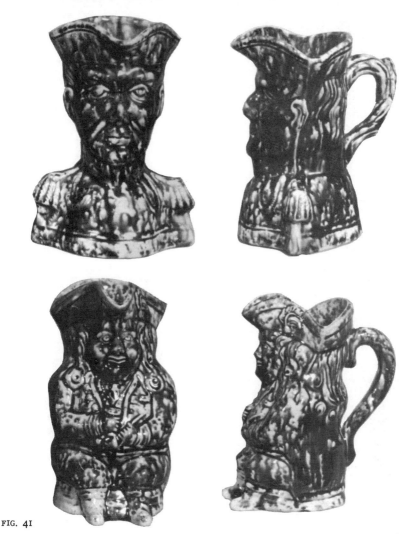

FIG. 4I

Question: Was there more than one design of toby pitcher made at Bennington? **Answer:** Yes, there were four different shapes, and one of these was made with two different handles, making a total of five different toby pitchers which were made in Bennington. The top and middle toby in Fig. 40 are basically the same design, except the top one has a grape-entwined handle (same as Fig. 41, bottom row) and the center one has a boot handle. This toby is called the "Ben Franklin" toby, for some unknown reason. The pitcher on top of Fig. 41 is the rarest design and is called the "General Stark" toby pitcher. All of these pitchers were made in Rockingham and Flint Enamel glazes, and about half of this production was marked with the 1849 mark in Fig. 6.

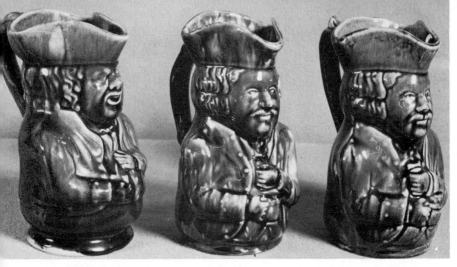

FIG. 42

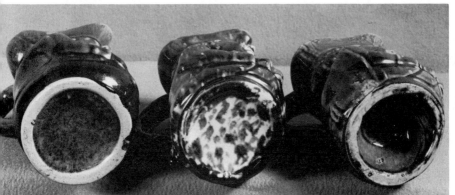

FIG. 43

Question: I have seen toby pitchers with differently shaped bottoms. Did Bennington make more than one bottom shape? **Answer:** No. The three tobys illustrated in Figs. 42 and 43 are all of a similar design, with different details. But the greatest difference is the bottom treatment shown in Fig. 43. Only the center toby (b) was made in Bennington. Toby (a) has many different details of design, but the easiest way to identify him as not coming from Bennington is the unglazed base-rim and slightly concave bottom. Toby (c) more closely resembles the Bennington-made one (b), but has a highly concave bottom in which you could put a small rubber ball. BE CAREFUL: Although all Bennington-made tobys have a glazed, flat bottom, all glazed, flat bottomed tobys do not necessarily come from Bennington. Be sure to match details of design with the five tobys known to have been made in Bennington.

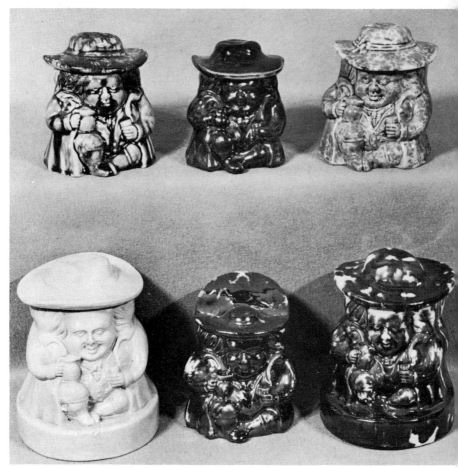

FIG. 44

Question: A dealer told me that Bennington made more than one kind of a toby snuff jar. Is this true, as I have only seen one design?
Answer: Yes, it is true, and you are lucky to have seen one design as this is one of the rarer items made at Bennington. They were made in different sizes, styles, materials and glazes. Fig. 44 shows all the known variations. Their heights range from 3⅞ inches to 5¼ inches. The center item (e) is not a jar, but is hollow without a bottom, hat attached. Jar (f), the rarest design, is on a base and is 5¼ inches high. The hats on all jars are removable covers. Occasionally the hat was made part of the base, with a slot in it, making it into a bank instead of a jar.

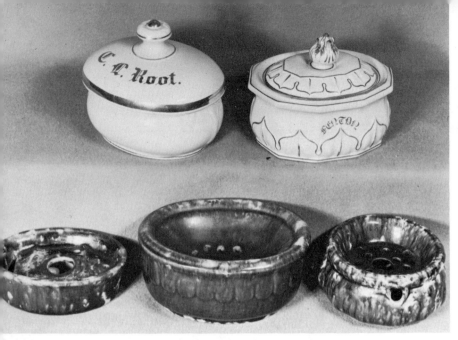

FIG. 45

Question: I frequently come across mottled-brown (Rockingham) soap dishes. These are in a great variety of sizes, shapes and designs. Did Bennington make more than one style soap dish? **Answer:** Yes. There were ten different shapes, three different materials and an almost un-limited variety and combinations of sizes. Soap dishes were a very popular production item. **Question:** I know that Bennington made many different styles of soap dishes, but how can I tell if the one I own was made there? **Answer:** The only way is to compare it with the known ones illustrated in Figs. 45, 46 and 47. Soap dishes were seldom marked, only two shapes ever having a mark recorded. They are the only brown, covered, soap dishes, shown in Fig. 46 (e) which is the same dish as Fig. 47 (b) and the Alternate Rib pattern dish in Fig. 47 (c). They both are three-piece soap dishes, with removable liners, and each is part of a large matching toilet set, including the covered toilet boxes illustrated in Fig. 46 (b) and Fig. 47 (a) and (d). **Question:** Did Bennington make solid brown soap dishes in addition to the mottled-brown (Rockingham) kind? **Answer:** Yes. They made two larger size soap dishes which have been recorded only with a solid brown (slip) glaze. They are the dish in the bottom center, Fig. 45 (d), which is 5¾ inches long, and the first one in the top row, Fig. 46 (a), which is 6¼ inches long. Both of these soap dishes were made at the Nórton pottery, as compared to the other ones which were produced by C. W. Fenton at his pottery. These two containers are fairly easy to find today.

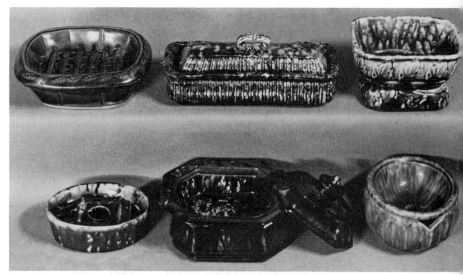

FIG. 46

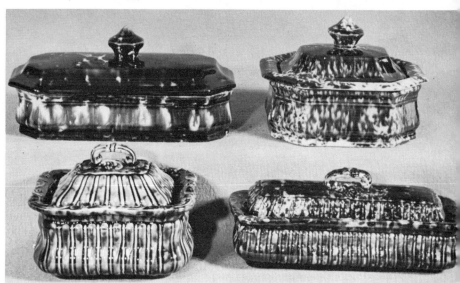

FIG. 47

Question: I have a shiny white covered soap dish which I was told was made in Bennington. Is this true? Answer: Yes, if it matches either of the two illustrated in the top row of Fig. 45 (a) and (b). These designs are the only two known to have been made in Graniteware. Both are three-piece, with a removable liner.

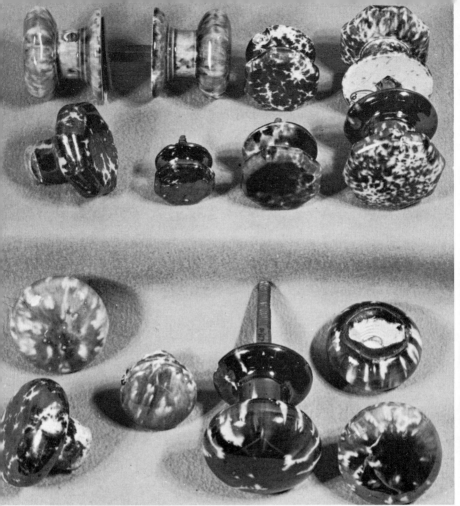

FIG. 48

Question: I live where brown door-knobs and drawer-pulls are very common. Yet I understand if they were made in Bennington, they are valuable. How can I tell Bennington-made knobs or pulls from all the other brown ones? **Answer:** This is difficult if they are the round variety illustrated in the lower half of Fig. 48, without the flared collar present in the knob with the iron rod. Bennington produced these knobs in Rockingham, Flint Enamel and Granite-ware. BE CAREFUL: You cannot tell where plain, shiny, white Granite-ware knobs were made; they are absolutely unidentifiable. If the knobs and pulls match the octagonal shape of the pairs of knobs in the top row, Fig. 48, they can be either Flint Enamel or Rockingham. BE CAREFUL: Bennington did NOT make a type of knob which is a veined, dark brown, covered in a solid clear glaze.

44

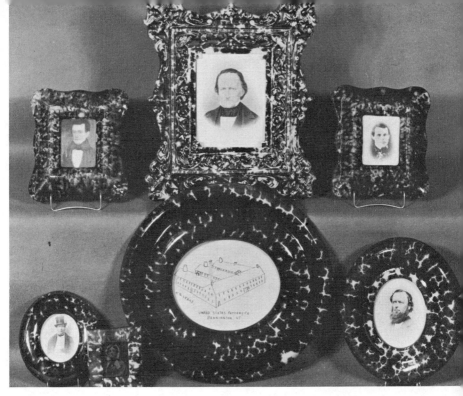

FIG. 49

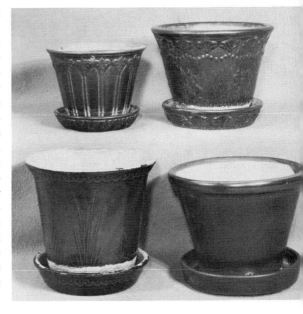

FIG. 50

Question: How can I tell if a picture frame was made in Bennington? **Answer:** I don't know of any other pottery which made frames like those shown in Fig. 49. Except for the elaborate one in the top row (b), the oval, round, rectangular and square frames were made in many sizes. Frame (b) is 11 inches high and 9½ inches wide. **Question:** Did Bennington ever make any solid brown, slip-covered flower pots? **Answer:** Yes, the Norton pottery did after the Civil War. They are fairly common, match those shown in Fig. 50, and date 1867-1894.

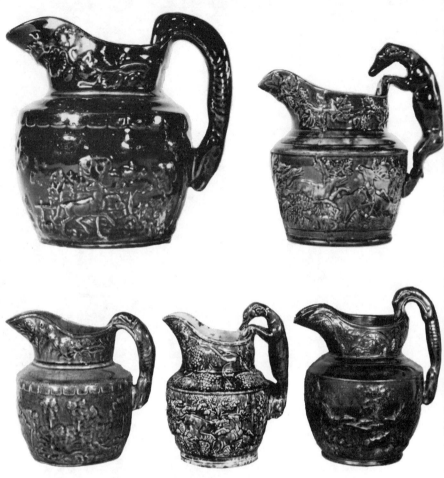

FIG. 51

Question: Did Bennington make a pitcher that had a dog-shaped handle? **Answer:** Yes, these are called "hound-handled" pitchers, and have always been very popular items. **Question:** Were hound-handled pitchers made any place besides Bennington? **Answer:** Yes, in England and Europe as well as all over the United States. Of the five illustrated in Fig. 51, only the center bottom pitcher (d) was made in Bennington. Pitcher (a) was made by Nichols & Alford, Burlington, Vt.; (b) was made by Harker, Taylor & Co. in East Liverpool, Ohio; pitcher (c) is by Nichols & Alford, Burlington, Vt.; pitcher (d) was made in Bennington, Vt.; pitcher (e) was made by J. B. Caire & Co., Po'keepsie, N. Y. BE CAREFUL: In order to have been made in Bennington, a hound-handled pitcher must have all four identification points listed under Fig. 52.

46

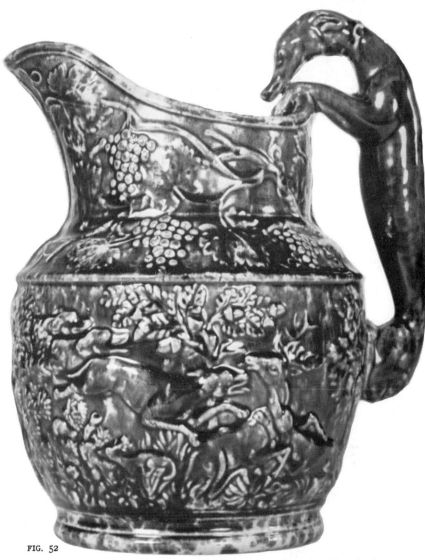

FIG. 52

Question: How can I identify a Bennington-made hound-handled pitcher? **Answer:** There are four points to look for, and all four MUST be present. 1. The hound's duck-billed nose touches the paws, but with the neck arched enough to allow one's little finger to fit underneath. 2. The hound must have a collar and it must be made of clearly defined links, not a strap. 3. The underside of the hound where the mold joined, is sharp—not flattened nor rounded. 4. You can feel the ribs, even if you can't see them. BE CAREFUL: All four points MUST be present; if one is missing, the pitcher was not made at Bennington.

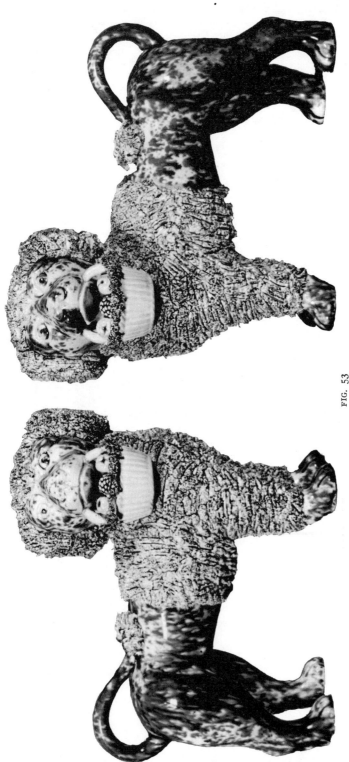

FIG. 53

Question: Did Bennington ever make a brown poodle sitting on its haunches? **Answer:** No. Those examples most frequently seen were made in East Liverpool, Ohio. Sitting poodles were also very popular in the Staffordshire district of England. **Question:** How can I identify a Bennington-made poodle? **Answer:** The poodles made at Bennington always held a basket of fruit in their mouths, and stood erect on four feet, as in Fig. 53, without a base. These poodles were made in brown Rockingham, Flint Enamel, Graniteware, and Parian. They vary in height from 8 inches to 9½ inches and were made in pairs, facing each other. BE CAREFUL: Remember, Bennington did NOT make a brown poodle sitting on its haunches.

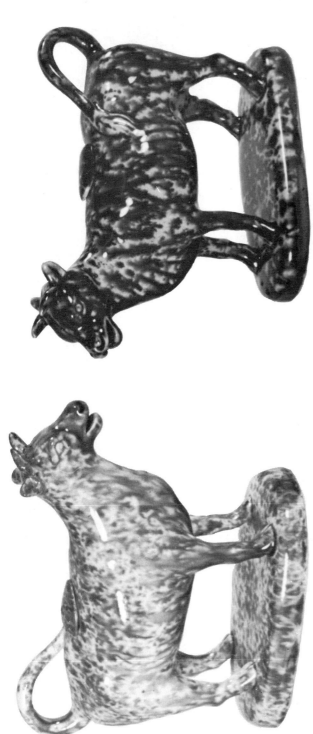

FIG. 54

Question: I know cow creamers were made at many potteries here and in England. How can I tell if mine was made in Bennington? **Answer:** There are five points to look for, each as important as the next, and all five must be present. 1. If brown in color, the brown must be mottled, not solid (were also made in Flint Enamel, Graniteware and Scroddled Ware). 2. Must have open, well-defined eyes—not half closed. 3. Must have crescent-shaped nostrils, not just a dot. 4. You must be able to feel folds in neck. 5. You must be able to feel ribs. Be CAREFUL: All five of these identification points MUST be present in a Bennington-made creamer. However, there were 900 copies made in England with these points, but are solid brown rather than mottled.

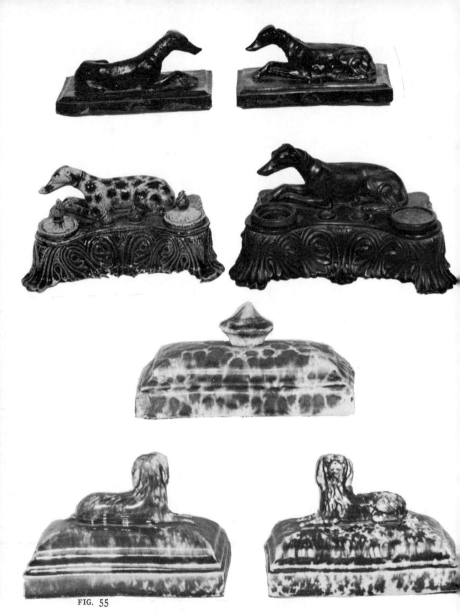

FIG. 55

Question: Did Bennington make seated dogs, other than poodles? **Answer:** Yes: this includes an inkwell, paperweights and a few small Parian greyhounds. BE CAREFUL: The greyhounds (a) and (b), top of Fig. 55, were made in West Sterling, Mass. The black inkwell (d) was made in England, identical in design with the Bennington-made spotted Stoneware one (c). The three paperweights (e), (f) and (g) were made in Bennington.

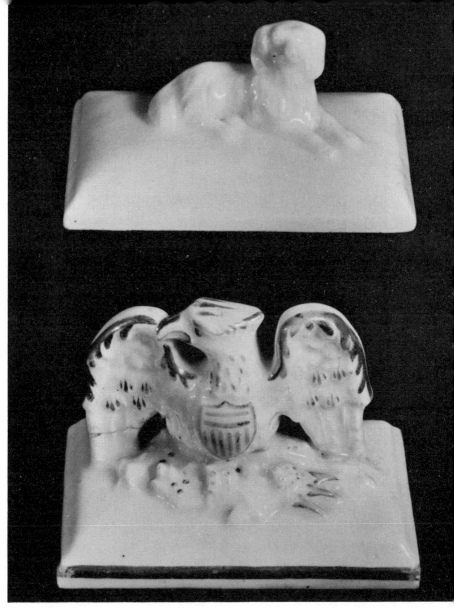

FIG. 56

Question: Did Bennington ever make paperweights other than the two brown designs shown in Fig. 55? **Answer:** Yes, a spaniel, Fig. 56(a), and an eagle, Fig. 56(b), were made in white Graniteware. These were sometimes decorated in gold or black, or sometimes left plain. BE CAREFUL: Eagle paperweights in Graniteware were also made at other potteries and closely resemble the Bennington-made ones.

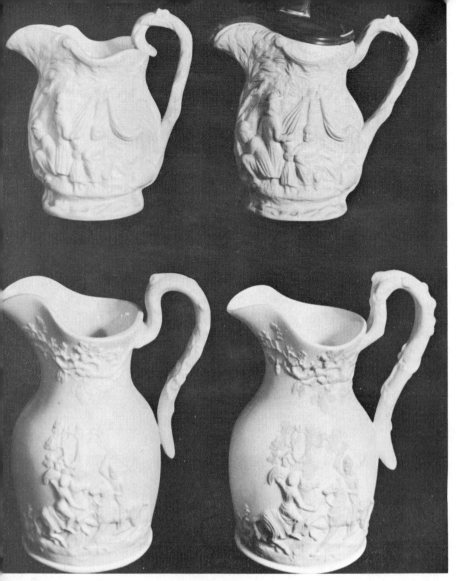

FIG. 57

Question: Can you identify Bennington-made Parian pitchers by their designs? **Answer:** Sometimes, but the items illustrated in Fig. 57 prove how false this identification method can sometimes be. Top right pitcher (b) was made in England by Jones and Whalley, while top left pitcher (a) is a Fenton piece from Bennington. Bottom left (c) is another Fenton pitcher from Bennington, while the pitcher on bottom right (d) was made by Samuel Alcock in England. BE CAREFUL: Don't use design alone as positive proof of place of manufacture.

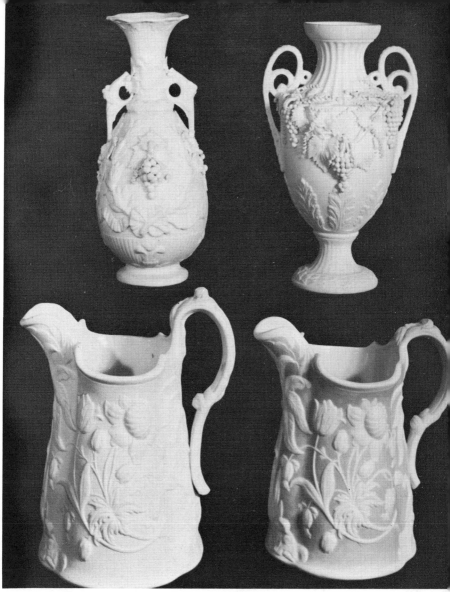

FIG. 58

Question: Was Bennington the only place which used applied grapes on Parian vases? Answer: No. Bennington copied this detail from many English potteries. Vase illustrated in Fig. 58 (a) was made in Bennington, the other vase (b) is English, probably Minton. Question: If Bennington copied from English wares, were Bennington-made wares ever copied? Answer: Yes. It was common for all potteries to copy each other. Pitcher (c) in Fig. 58 is a Bennington-made copy, dating 1852-1858, while pitcher (d) was made in 1873 by L. W. Clark Co., Boston.

53

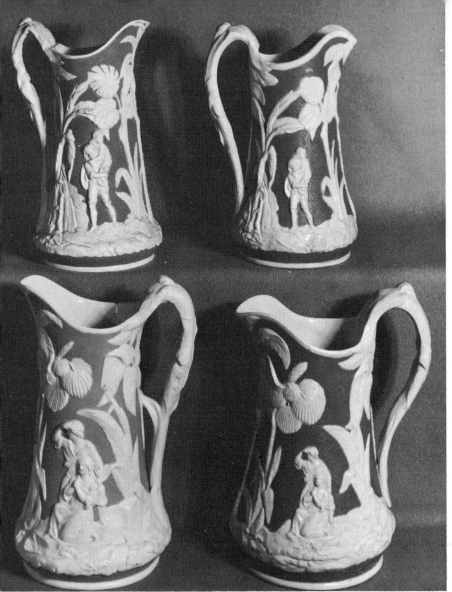

FIG. 59

Question: If you can't use design for identification, what can you use?
Answer: Don't use design alone, but analyze portions of it. The "Paul and Virginia" pitcher in blue and white porcelain in Fig. 59 provides a good example. The two pitchers on the left (a) and (c) were made by T. J. & J. Mayer in England. The two on the right (b) and (d) were made in Bennington. They are all of the same design, but close inspection reveals many differences in the small details. The easiest to remember are shown close-up in Figs. 61 and 62.

54

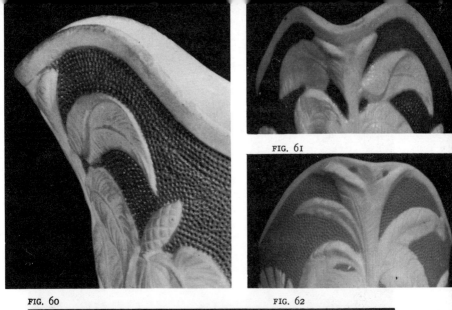

FIG. 60

FIG. 61

FIG. 62

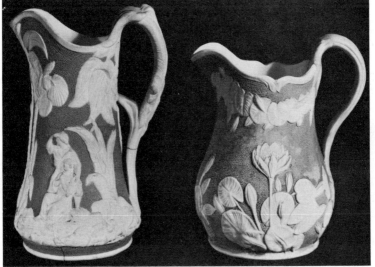

FIG. 63

Fig. 61 shows the spout WITHOUT two spots of color near the lip. This was made in Bennington. Fig. 62 shows another spout, WITH two spots of color near lip. This was made in England (T. J. & J. Mayer). Another clue is shown in Fig. 60. Most Bennington blue and white porcelain has a pin-point background to the blue, which follows the design, while the English pin-points are usually in regular, even-spaced rows. Both pitchers in Fig. 63 were made in Bennington and are typical of this type of production.

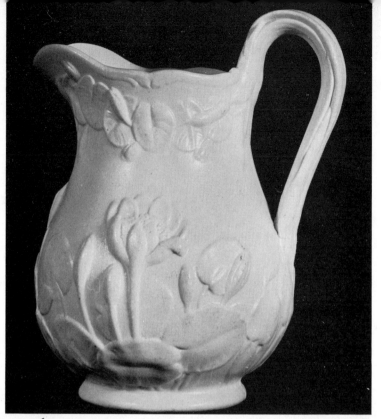

FIG. 64

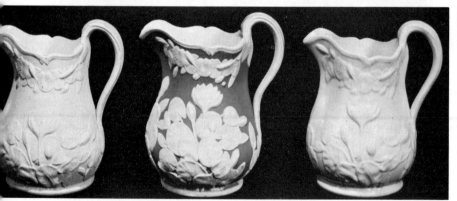

FIG. 65

BE CAREFUL: "Pond Lily" design pitcher in Fig. 64 was made in England by Copeland. All three "Pond Lily" pitchers in Fig. 65 were made in Bennington. This design is usually marked with the U.S.P. ribbon mark shown in Fig. 9. Bennington-made pitchers in this pattern all have pin-point backgrounds regardless of color.

56

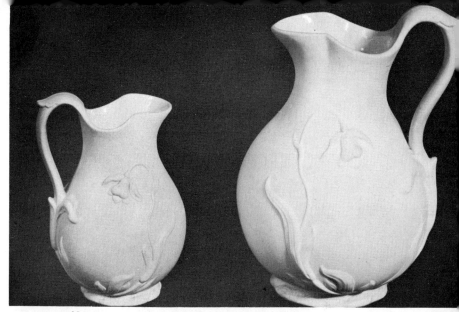

FIG. 66

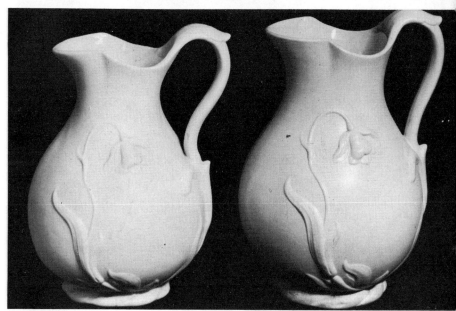

FIG. 67

BE CAREFUL: Rare "Snowdrop" design Parian pitchers are difficult to identify if not marked with Fenton mark in Fig. 10. **Top two in Fig.** 66 were made in Bennington as was bottom left, Fig. 67(a). **Bottom right, Fig. 67 (b)**, is English and was made in light blue-gray shown, as well as in Parian.

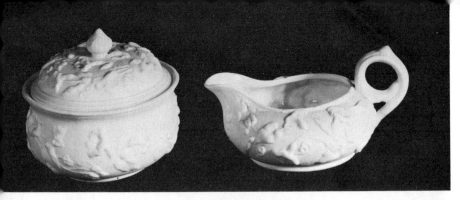

FIG. 68 ↑

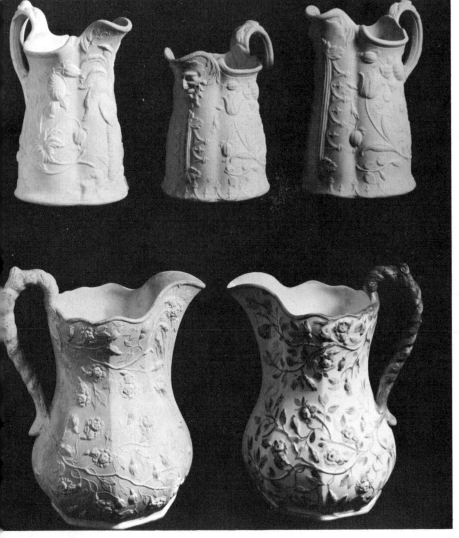

FIG. 69

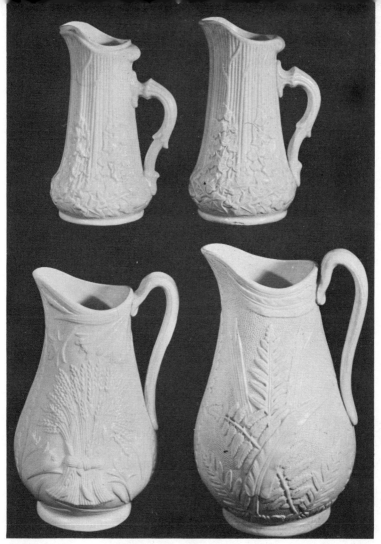

FIG. 70

BE CAREFUL: Items illustrated in Figs. 68, 69, and 70 were all made in Bennington, but similar designs were made in England. Be sure to compare minute details with illustrations to make certain they are identical. The creamer and sugar bowl in "Morning Glory" pattern, shown in Fig. 68, is a copy of a Minton design. The top three pitchers in Fig. 69 are Bennington variants of "Tulip and Sunflower" pattern. See also Fig. 58 (c) and (d): notice especially the under-lip designs. Bottom two pitchers, Fig. 69 (d) and (e), are "Wild Rose" pattern which is usually in Parian, but (e) is rare example glazed in colors of red, yellow, green, and brown. Pitchers in Fig. 70 are Graniteware, usually white or light gray, when marked as in Fig. 11. Pitchers (c) and (d) were also made in gray-green or light blue.

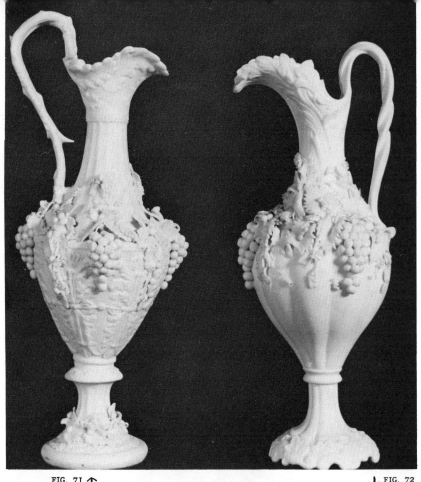

FIG. 71 ↑ ↓ FIG. 72

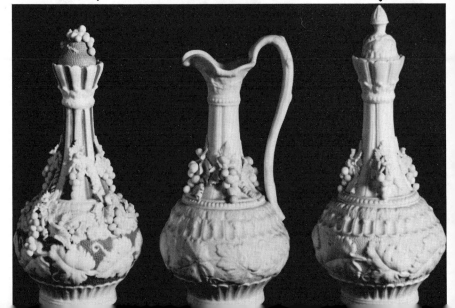

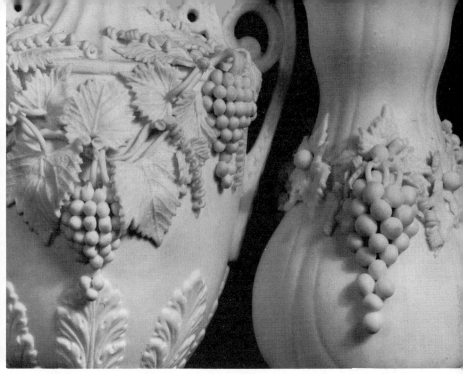

FIG. 73

Question: If Bennington is not the only place where grapes were applied to Parian vases, how can I tell if my vase is Bennington-made? **Answer:** Usually, although not always, English-made grapes are smaller and more perfectly formed, as shown in Fig. 73. The left vase (a) is English—see also Fig. 58 (b)—while the example on the right, Fig. 73 (b), was made in Bennington. Notice also that English leaves have more small veins and many more stems than were used in Bennington. BE CAREFUL: You cannot always identify a grape-decorated vase by the grapes alone. But you can be sure that very small, perfectly shaped grapes were made in England. **Question:** Were there any particular shapes or forms that are typical of Bennington grape-decorated vases? **Answer:** There is no one typical shape or form by which Bennington vases may be identified. All pieces shown in Figs. 71 and 72 were made by Fenton in Bennington. The ewers in Fig. 71 are typical of their type, but this is no clue to identification. Fig. 72 shows how the shape and form of a cologne bottle can be changed to an ewer; also how a Parian piece can be changed to blue and white porcelain. See also Figs. 74 and 75. All of these pieces could be called typical production. As a general rule, the very sophisticated designs came from England, while the Bennington-made pieces are a little less skillful in manufacture. This fact is not always an easy clue to use, however.

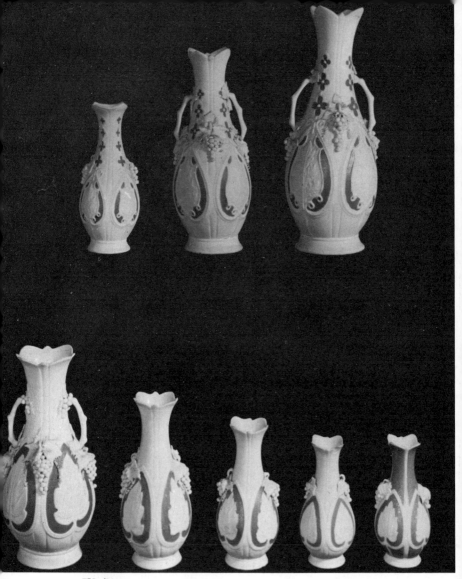

FIG. 74

Question: How can I tell if my grape-decorated vase was made in Bennington? **Answer:** There is no one easy way. The porcelain vases made at Bennington, of which those illustrated in Figs. 74 and 75 are typical, were very popular. Fenton's pottery produced literally hundreds of variations. Fig. 74 is a good example of the change in details. Vase (a) has no handles, two bunches of grapes and four blue crosses high on neck. Vase (b) has handles, four bunches of grapes and only three crosses high on neck, and vase (c) is taller.

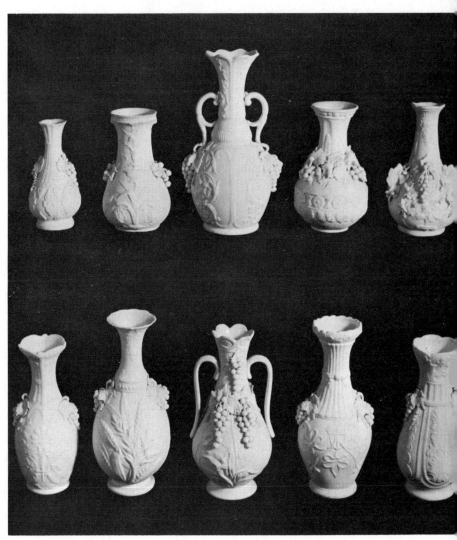

FIG. 75

BE CAREFUL: The vases on these two pages clearly show how varied was the Parian production at Bennington. The only way to identify your vase as having come from Bennington is to compare it with known Bennington production. My large book, *Bennington Pottery and Porcelain,* illustrates several hundred known examples of design, but not in every known size. It is recorded that as many as seven different sizes of the same design were made. Parian vases encompass the largest field of different designs that were made at Bennington.

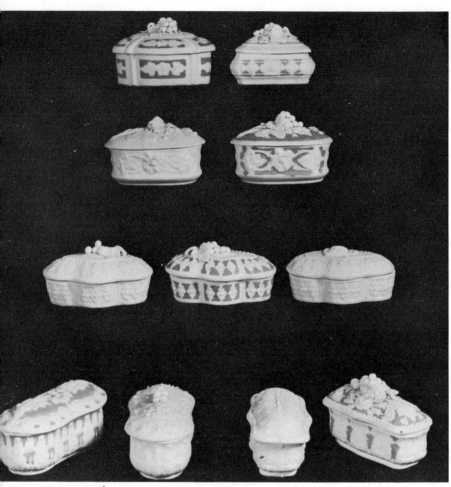

FIG. 76

Question: How can I tell if the Parian trinket box I own was made in Bennington? It isn't marked in any way. **Answer:** There are more than 130 basic designs known to have been used on trinket boxes in Bennington. Add to this the many varieties found in each design: Parian, or blue and white, or glazed; with grapes, without grapes; with flowers, without flowers, etc.; and you can treble this number at least. Add also that there has never been a marked trinket box recorded and you can see how impossible it is to identify a Bennington-made trinket box unless you can compare yours with a known Bennington product. BE CAREFUL: Trinket boxes were popular production items at English potteries also.

64

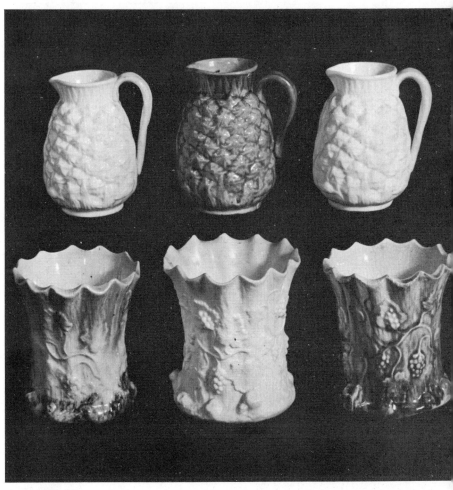

FIG. 77

Question: I've been told that Bennington made majolica. Is this true and how can I identify it? **Answer:** A majolica-type glaze was used on an experimental level at Bennington sometime between 1847 and 1858, although it is not true majolica pottery. Only two designs have been recorded, the pineapple-shaped pitcher in Fig. 77 (all three are 3¾ inches high); and the scalloped, squat vase with molded grapevines (4 inches high). Pitcher (a) is highly glazed porcelain and pitcher (c) is Parian; vase (e) was made in Parian also. Be careful: It has not yet been determined if these items were made in any other sizes than those recorded above, or if majolica-type glaze was used on any other items.

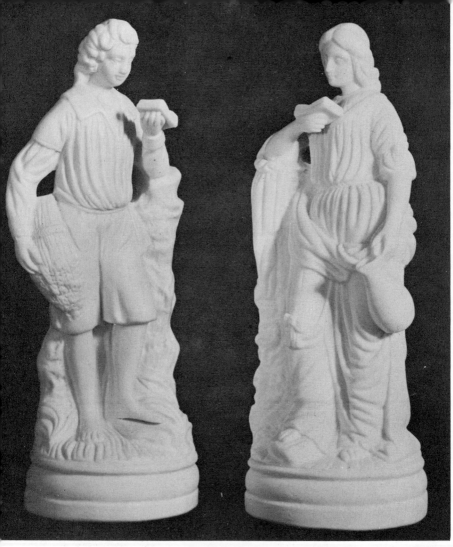

FIG. 78

Question: I have a Parian statuette and I would like to find out where it was made. How can I do this? **Answer:** I don't know! Parian statuettes are the most difficult items made at Bennington to identify with accuracy. Note the short list in Fig. 3 of statuettes made in production quantities in 1852. We know these became more popular and new designs were introduced; but also they were being produced elsewhere in the United States and in England. Figs. 78 to 82 will illustrate how impossible it is to attribute production to Bennington without matching your statuette with an identified piece.

66

FIG. 79

BE CAREFUL: Pictured above are the bottoms of seven known Bennington-made Parian statuettes, and all seven are different! There is no one type of bottom which is a sure sign of Bennington origin. Also, remember that there is no known example of a Bennington-made Parian statuette being marked, except "Red Riding Hood" in Fig. 82. Further, Parian statuettes with the same designs and Bennington histories are known to have been made with several different treatments of inside and bottom. Comparison with known examples is the only safe method of identification, and this has pitfalls.

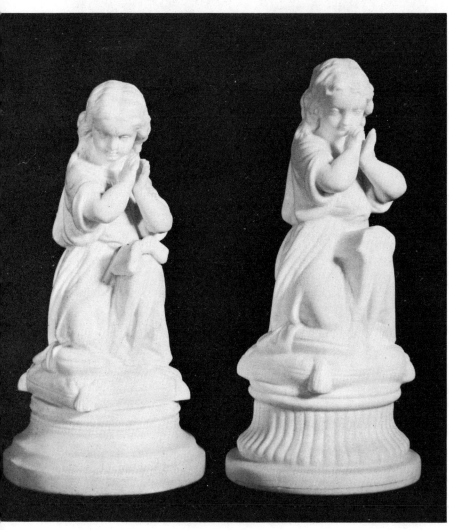

FIG. 80

Question: Is it impossible to identify any Parian statuettes as having been made in Bennington? **Answer:** No, there are a few dozen designs which may be identified by comparing the details. But this must be done with intelligence and care. Notice the two figures on different bases illustrated in Fig. 80. Both are known to have been made in Bennington, but comparison of the two will disclose many different details, especially in the drapery folds. BE CAREFUL: Compare statuettes of same basic design, as Bennington usually made several variations of the same pattern.

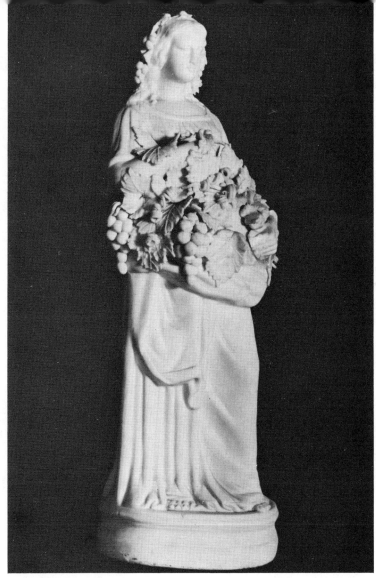

FIG. 81

BE CAREFUL: Compare elaborate applied decorations on Parian statuette "Autumn" in Fig. 81 with the complete lack of decorations on "Praying Girl" in Fig. 80. Note also difference in the three base treatments. Yet all three were made in Bennington. The grapes in Fig. 81 can serve as a clue, but cannot be the only point of identification. This statuette is 13 inches high, but is known to have been made in other sizes. It cannot be stressed too much that it is often impossible to identify place of manufacture of Parian statuettes.

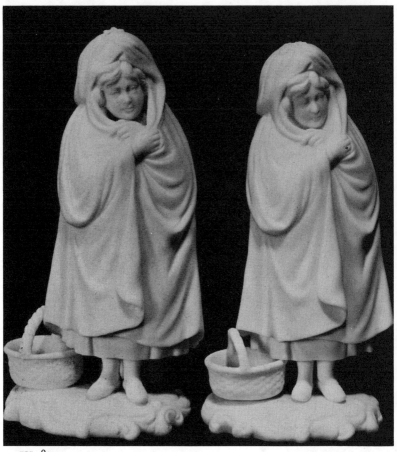

FIG. 82

BE CAREFUL: After all the warnings for the past four pages concern-
ing the difficulty of identifying Parian statuettes from Bennington,
it seems fitting to include a comparison of the two "Red Riding
Hood" statuettes in Fig. 82. The statuette on the left (a) was made by
Minton in England and is so marked. The statuette on the right (b)
was made at Bennington and is marked with Fenton's mark in Fig.
10. This is the only known Bennington-made statuette to be marked.
Close comparison will reveal that the English piece on the left has
a deep recess around the chin, between the face and the hood, while
the Bennington piece is flatter there, without the depth of that
detail near the chin. There are other differences, but this is the
most obvious. Examples of both statuettes have been found unmarked.

Question: What are some of the characteristics of Bennington-made Parian statuettes? **Answer:** There are a few clues which, if you remember to regard them only as an indication and NOT as a positive identification, will at least serve to eliminate some statuettes. Bennington did not produce elaborate groups of several figures together. All of Bennington's pieces are individual statuettes, although often produced in pairs such as boy and girl, man and woman, etc. Frequently you will find tiny black specks throughout the body of the piece. This is also true of items other than statuettes. It is the result of impurities in the kaolin, usually the oxide of iron, which were invisible before the piece was fired but showed up as burnt specks when the item was removed from the kiln. Bennington-made statuettes in Parian are of an unsophisticated design, with simple, plain, pleasing features. No attempt is made at exact portraiture. Actually much better Parian figures were made elsewhere, Bennington production being made mainly in simple designs.

As you will have learned from this text, this basic lack of sophistication is a characteristic of most of the extremely varied production at Bennington between 1847 and 1858, the peak years at the Fenton Pottery.

INDEX

NUMBERS REFER TO PAGES